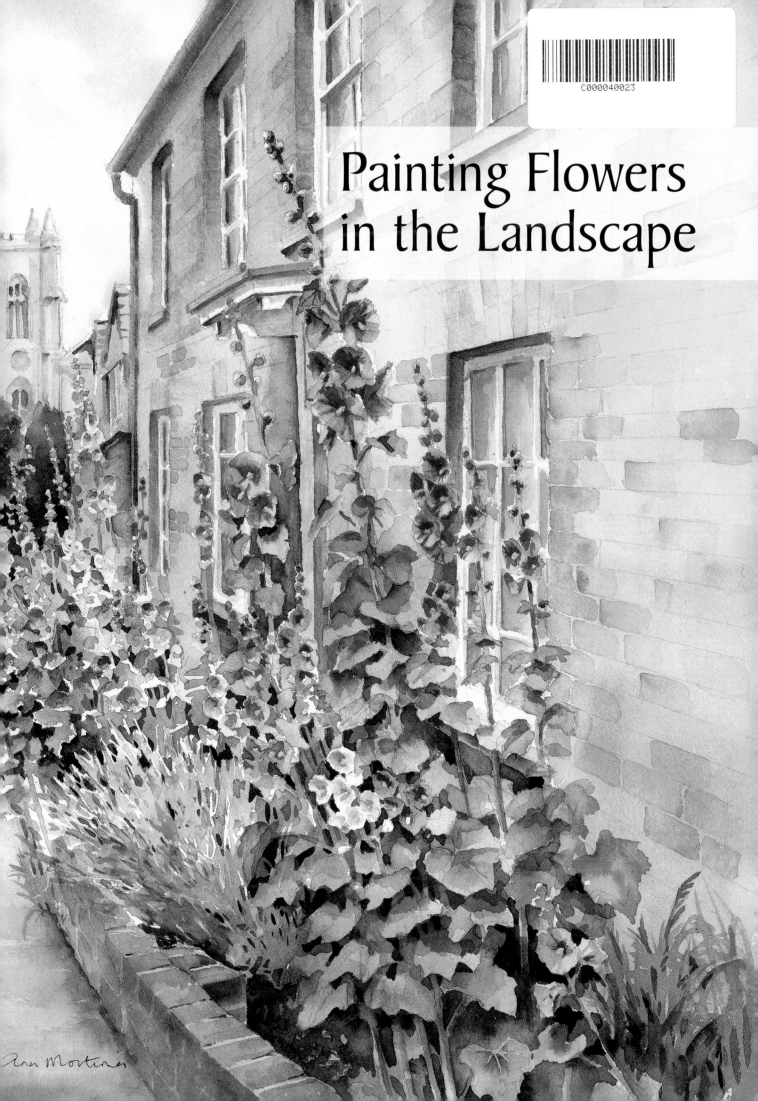

Painting Flowers
in the Landscape

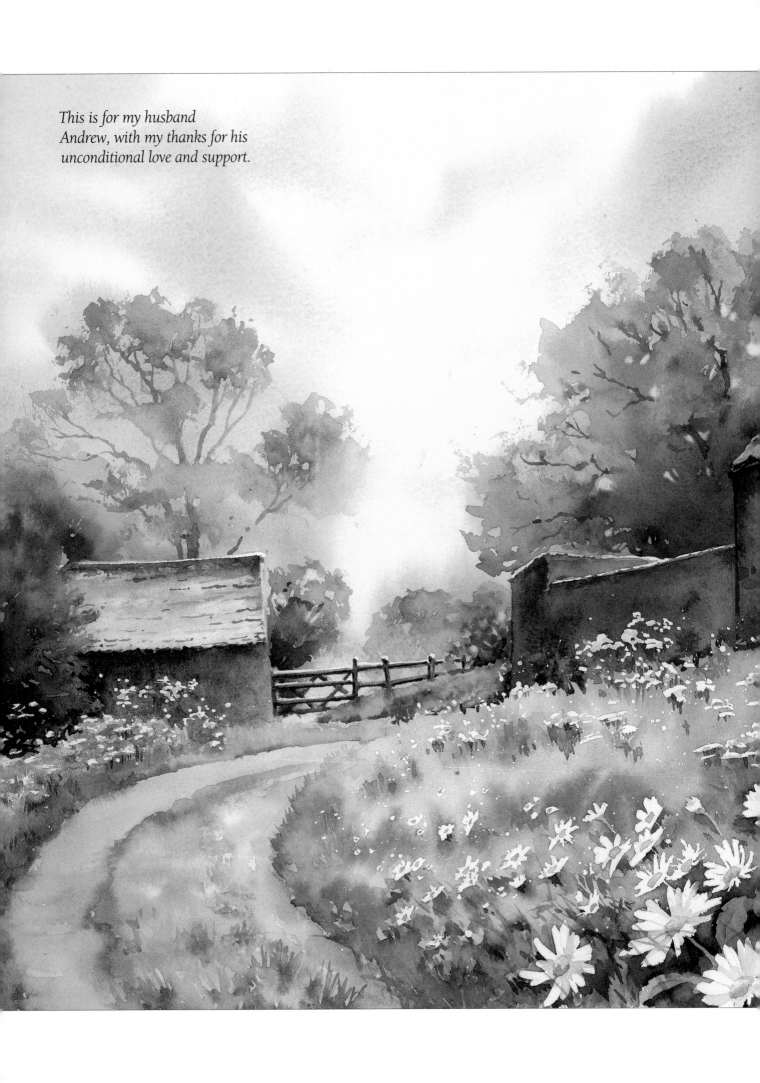

This is for my husband Andrew, with my thanks for his unconditional love and support.

Painting Flowers
in the Landscape

ANN MORTIMER

SEARCH PRESS

First published in Great Britain 2009

Search Press Limited
Wellwood, North Farm Road,
Tunbridge Wells, Kent TN2 3DR

Text copyright © Ann Mortimer 2009

Photographs by Debbie Patterson at Search Press studios

Photographs and design copyright © Search Press Ltd 2009

ISBN: 978-1-84448-331-0

The Publishers and author can accept no responsibility for any consequences arising from the information, advice or instructions given in this publication.

Suppliers
If you have difficulty in obtaining any of the materials and equipment mentioned in this book, please visit the Search Press website for details of suppliers: www.searchpress.com

Acknowledgements
I would like to thank Roz Dace for giving me this opportunity, Edd Ralph for his patience, forebearance and sense of humour and all of the team at Search Press for their friendly help.

Thanks also to my daughter, Sophie, and sons, Stephen and Christopher, who have all given their time and attention to support me in my art work.

My special thanks go to my friends Margaret and Bernard, whose lovely garden has often been a source of inspiration for me.

Finally, thanks go to all my students who, unknowingly, have taught me so much!

Publishers' note

All the step-by-step photographs in this book feature the author, Ann Mortimer, demonstrating how to paint flowers in watercolour. No models have been used.

There are references to sable and other animal hair brushes in this book. It is the Publishers' custom to recommend synthetic materials as substitutes for animal products wherever possible. There is now a large range of brushes available made from artificial fibres, and they are satisfactory substitutes for those made from natural fibres.

Front cover
Riverside Hollyhocks
37 x 27cm (10½ x 14½in)
The composition of this painting is looked at in more detail on pages 24–25.

Page 1
Hollyhocks at Stoke by Nayland
26 x 37cm (10 x 14½in)
The majestic stems of hollyhocks en masse make my heart leap! The hollyhocks are the main subject of this painting. However, I felt the house was important contextually to this particular picture and so have painted it in detail. For a different composition, the house could be merely hinted at.

Pages 2–3
Wildflowers at Castle Rising
43 x 35cm (17 x 14in)
*This was a very sunny day in Norfolk and my painting has romanticised the scene somewhat. It was important to capture the sunshine falling on the barn roofs and fence, so the areas were protected in the early stages with masking fluid.
The daisies and cow parsley were also masked out. The trees were given a loose treatment to make them recede.*

Opposite
Farm Gate
27 x 35cm (10½ x 13½in)
*This gate, in a village where I hold a watercolour class, caught my eye. I liked the way the scene was backlit so that the gate was silhouetted against the sunlight. I masked out the gate before laying the first washes to achieve this effect.
The flowers were not actually there! I referred to my collection of reference photos to help me paint them.*

Contents

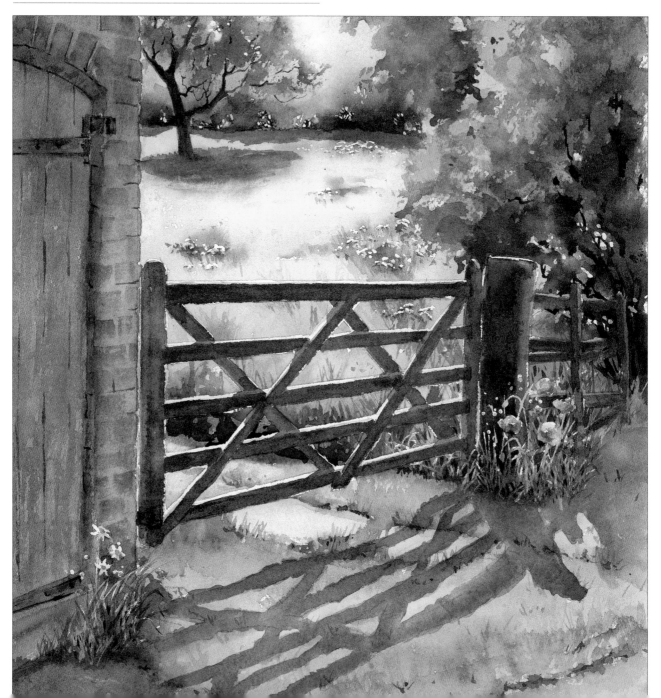

Introduction

Painting flowers in the landscape conjures up images of country lanes, townscapes, gardens, lakes, rivers: the list goes on. In a landscape painting, flowers can provide a focal point or a surprising juxtaposition. They can add character and colour to a scene or suggest a hidden human presence.

Flowers grow everywhere if given a chance. Giant hollyhocks emerge from the smallest crack between city paving slabs, while massed bluebells cover huge swathes of woodland floor in misty carpets of blue. Everywhere you look, there are flowers: window boxes full of bright red geraniums, market stalls brimming with carnations and chrysanthemums, embankments sparkling with ox-eye daisies, seaside cliffs speckled with hardy thrift, pavements outside grocers' shops littered with punnets of pansies, not to mention town parks with their proud displays and front garden paths edged with multicoloured annuals.

Flowers are with us throughout the year. They bring hope of new awakenings in spring and swoon fragrantly through long hot summer days. They herald the harvests of autumn and bring cheer to the dark days of winter.

Flowers are indeed hard to ignore. They brighten our lives and our surroundings, and I can think of no better medium to use to paint them than watercolour because it is such a lively and dynamic medium. Learning to control it – or should I say to not control it too much – is a challenge. It is, however, all the more fun for being so. Watercolour reveals its secrets gradually to anyone who is prepared to give it a go. As a medium it can be surprising or exasperating, but it is always fascinating and ultimately rewarding.

Watercolour is what it says: colour moving through water. There is nothing better than to watch colours mingling in water upon a beautifully textured white surface and seeing the pigments settle into unexpected textures. Even the equipment itself make you want to start painting; that sheet of pristine white grained paper, the fine sable brush, the jewel-like colours glistening in the palette. You just cannot wait to get started.

My hope is that this book will have something for everyone, inspiring you to look for more opportunities for painting the landscape, and that the tips and techniques will help you to enjoy all your future watercolour adventures.

April Hellebores
33 x 25cm (13 x 10in)

These hellebores were growing in front of a hedge in my garden. Chinks of light were visible through the hedge. I masked these out as well as the main flowers. I used aureolin, green mixes, alizarin crimson and burnt sienna in a loose first wash, and was careful to leave areas of yellow shining through in the finished picture. The speckles in the flowers are alizarin crimson.

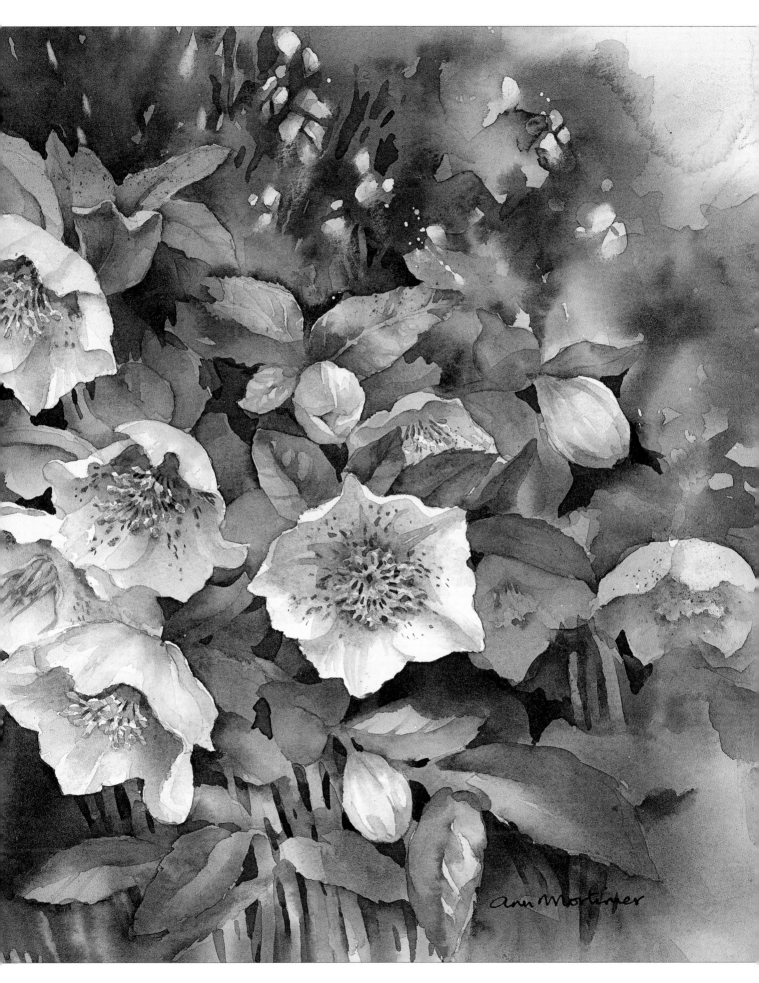

Ann Mortimer

Materials

PAINTS

Watercolours are available in students' and artists' quality. There is a difference in price between the two which reflects the difference in quality. Put very simply, artists' quality paint has more pigment and more transparency than students'. Do not think that you have to start with students' quality because you are a beginner or inexperienced. I would recommend buying the best paint that you can afford.

Regardless of which you choose, it is a good idea to buy tubes rather than a paintbox full of pans (hard tablets of paint). It is a false economy to buy a box with a large range of colours in it, most of which you will probably never touch. I think it much better to buy a few tubes of colour and an inexpensive plastic palette with a lid, into which you can squeeze colour from the tubes.

Start with three or four tubes: a yellow, a blue and a red, and an earth colour (such as burnt sienna). As you mix your colours and experiment, you will see how many different shades you can produce with these basic colours. You will also soon see which extra colours you might need, such as a pink or a violet, depending on the subjects you choose to paint.

Squeeze each colour into one of the small sections of the palette and use the large sections to mix your colours. That way you will experience from the start the joy of dipping your brush into soft colour instead of wearing your brushes out trying to work up colour from small pans of hardened paint.

I keep my tubes of paint in a tin and replenish my palette frequently to keep the paint fresh and moist.

PALETTES

This is my palette. I squeeze colour out of the tubes into the small sections. I have the colours arranged with yellows, blues and reds together in a sequence vaguely resembling the colour wheel. The palette has a hinged lid which makes it easy to transport.

I think it is important for the colours to be glistening and fresh, so on most days I wash the palette under a thin stream of water from the cold tap. This keeps the colours and the palette clean and serves to dampen and freshen up the paint without washing it away. It is vital for me to be able to dip my brush into soft paint.

TIP

If you always keep your colours in the same position in your palette, you will gradually get to know their names and be able to distinguish each colour from the others.

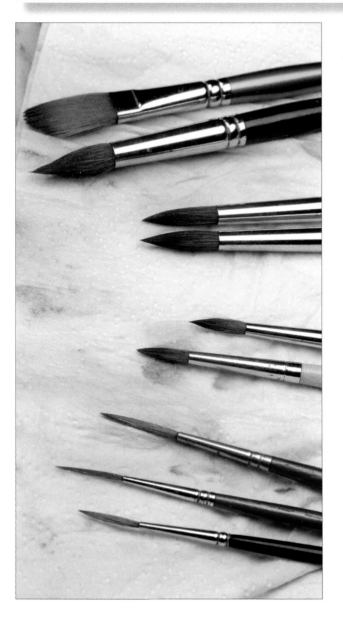

BRUSHES

Your brush is a very important piece of equipment. It is an extension of your hand. It has to be a sensitive tool which can interpret the creativity that travels down your arm from your brain!

The longer I paint in watercolour, the more I realise how important brushstrokes are. You cannot make sensitive marks with a cheap, badly made brush. It is not for nothing that brush makers have spent centuries perfecting the ideal vehicle for carrying watercolour. So please, do not buy that bargain lot of cheap brushes: spend the money on one well-made brush.

I use a range of brushes, both sable and sable/synthetic blends. These brushes hold a good amount of pigment and water and allow you to lay generous washes and manipulate the paint sensitively, giving you great control.

Most of the time I use a size 10 and a size 6 round brush with a good point for the main body of the work, and riggers and flats to render details such as twigs and brickwork.

In addition to these, I use a small flat acrylic brush to lift paint, scrub out unwanted areas or to soften edges, a large synthetic filbert for wetting the paper and a size 12 round sable for laying in the first washes.

I often have two brushes on the go at the same time: one to lay the wash and another 'back-up' brush – clean and dipped in water – to spread and blend the wash.

Sketchbooks

The word 'sketchbook' conjures up visions of the Edwardian country lady and her beautifully observed and annotated drawings of nature together in a bound album. I have often yearned to be able to keep a similar journal and to make sketching forays into local fields and woodlands, but then I remind myself that the Edwardian lady in question would undoubtedly have employed a nanny to look after the children and that the servants would have prepared roaring fires and made dinner in time for her return!

It is difficult to make time for sketching, but I always manage to do some sketching when on holiday, away from the concerns of everyday life. I sometimes feel I do not sketch enough: the reward of looking through old sketch books and seeing the fresh, spontaneous work is always an inspiration, so there is no doubt in my mind that we should all keep a sketch book. I like the A4-size hardback sketchbooks with cartridge paper inside, as these are very sturdy: an important quality when filled with pencil, pen and watercolour sketches.

In addition to allowing us to practise our drawing skills, the other main reason I use a sketchbook is to prepare tonal sketches and to try out different compositions before starting to paint. These are worth keeping for future reference.

Remember that there is no pressure to produce a great masterpiece in a sketchbook, and as a result we can often produce our most spontaneous and relaxed work.

Paper

Using good-quality paper makes all the difference to your work and helps you to enjoy the painting process, so producing a better result. It is so important to have a sturdy, well-made textured surface upon which to lay washes, so I would recommend using a recognised brand of good-quality watercolour paper every time; think of it as an investment towards your future skills. At the same time you will enjoy the experience so much more.

Practising is the time you most need the techniques to work, or you may be put off by failures. These are often due to using inferior paper, so I am wary of so-called 'practice paper'.

For the paintings in this book I have used paper with a Not or Rough surface. As far as weight is concerned I have used either 300gsm (140lb) or 425gsm (200lb) paper.

I do not generally stretch my paper. I can use wet washes on the 425gsm (200lb) paper without it cockling too much, and so that is my preferred weight.

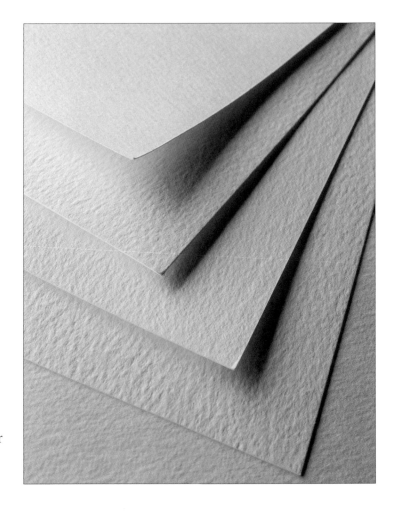

OTHER MATERIALS

Apart from the board, the following equipment all fits into my painting bag. I carry it all everywhere I go when painting, teaching or doing demonstrations.

A **board** is essential to keep your paper flat and to make the painting portable. It is easily picked up and moved about to allow washes to spread and merge. It needs to be 5cm (2in) bigger all round than the paper you are using.

Masking tape is useful for attaching paper to the board along all four sides.

I use Winsor and Newton **masking fluid** and keep a **nylon brush** with a good point to apply it. I always carry a piece of **soap** in a tin to coat the brush with before dipping it into the masking fluid.

Colour shapers are good for using with masking fluid for fine lines such as stamens.

I always have several sheets of **kitchen paper** under my brushes so I can control the amount of water on the brush by dabbing it on the paper.

I use a **2B pencil** to draw the composition and use a **4B** and **6B** for sketching and shading.

I use fine-tipped nonpermanent black **pens** for my initial sketches.

To create textures, I use **salt** and a **sponge** and I use **candles** for wax resist effects.

Tissues are always at hand for soaking up drips and sometimes to create texture in a wash.

A **toothbrush** and **palette knife** are useful for spattering.

I use a **putty eraser** to remove pencil marks.

A **spray bottle** is used to re-wet paper when laying in an initial wash.

I use a **craft knife** for scratching out highlights and sparkles on water surfaces.

I use a lightweight expanding **water pot** and **enamel cup** to wash my brushes and provide clean water for painting.

A **hairdryer** is used to encourage washes to dry, and completes my battery of equipment.

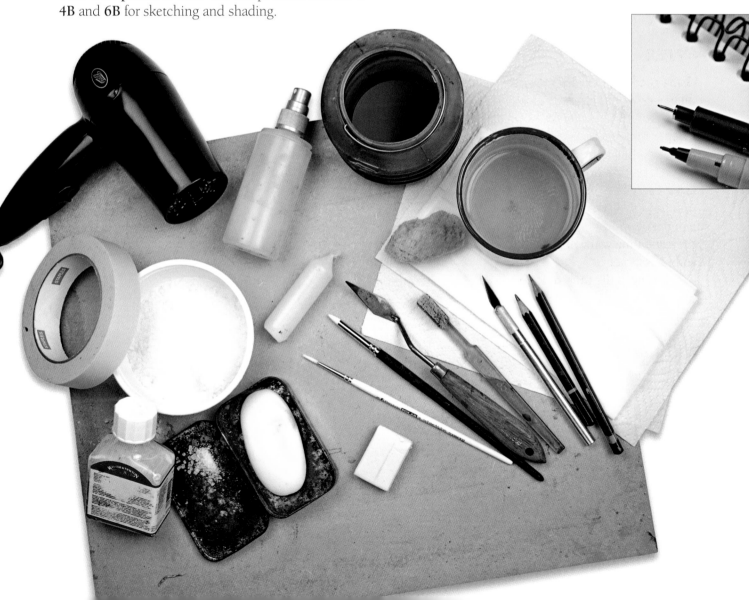

Using colour

MY PALETTE

These are the colours I have in my palette and I use them all regularly. The nine colours I have marked with an additional smaller swatch would make a good starting palette for a beginner. They include a mixture of warm and cool yellows, reds, blues and one green.

Aureolin yellow

I often use this clean, bright yellow in my initial washes. To me it represents sunshine on leaves and in the background. It can also be used as a glaze to brighten colours underneath.

Raw sienna

A major player in my palette. I combine this with aureolin to make a more interesting yellow, or with blues and pinks for stonework. It is also a good base colour for tree trunks.

Transparent yellow

This is a useful translucent colour for yellow flowers such as daffodils.

Indian yellow

This yellow can be combined with alizarin crimson to make warm red and orange mixes for the shadow areas of yellow flowers.

Quinacridone gold

This is a useful colour to mix with blues to create natural greens.

Burnt sienna

This is a versatile colour. Combined with blues it makes great darks, and it also make greens look more natural.

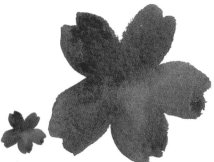

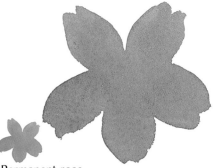

Alizarin crimson

This is a cool red which is a useful basic colour to have in the palette. I drop it into raw sienna, wet-into-wet, for stalks and use it with gold to create autumnal shades.

Perylene maroon

I use this robust colour combined with blues and greens to make vibrant darks.

Permanent rose

This is a must for flower painters to use in delicate first washes and to mix with blue for shadows.

Quinacridone magenta

This is a clean, strong pink indispensable for flower painters.

Winsor violet

I like to mix this with blues and pinks for translucent darks.

Winsor blue

A cool blue which works well with Winsor violet for bluebells. When mixed with yellows, it is also a good base for clean greens.

Cobalt blue

This with a touch of permanent rose makes a good shadow colour for white flowers. It is also a mainstay for skies: on its own or with a touch of pink or violet.

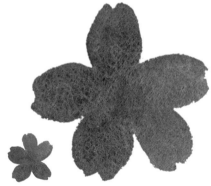

French ultramarine

One of my main uses for this is combined with burnt sienna for darks in trees, twigs and stone walls.

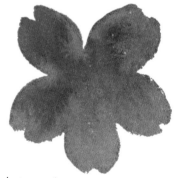

Phthalo turquoise

I use this mixed with reds and golds for making clean non-muddy darks.

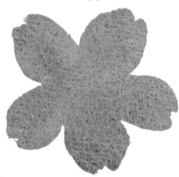

Viridian

This can be combined with burnt sienna for natural greens or with pink for beautiful greys.

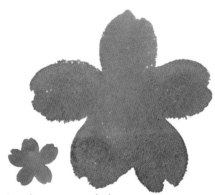

Hooker's green dark

A useful clean bright green which can be combined with yellows or reds for more natural greens.

Sap green

I use this combined with yellow as a quick solution for grasses and young leaves.

COLOUR MIXING

There are many bright colours available nowadays. However, in my experience, students often protest that they find it difficult to achieve successful colour mixes.

I often think that it is the way colours are mixed that is at fault rather than the choice of colours. Perhaps we should call the action mingling or combining rather than mixing. It is all too easy to create a muddy grey-brown by mixing colour too energetically. I advise treating the colours with a bit more respect!

Try laying the colours side by side in the palette and then gently combining them in the middle. Do not over-mix the paints as this will make them muddy. Three or more colours should be visible at the same time in the palette. While working on a painting, the palette should ideally look like a version of the finished painting with a range of fresh colour combinations ready for use.

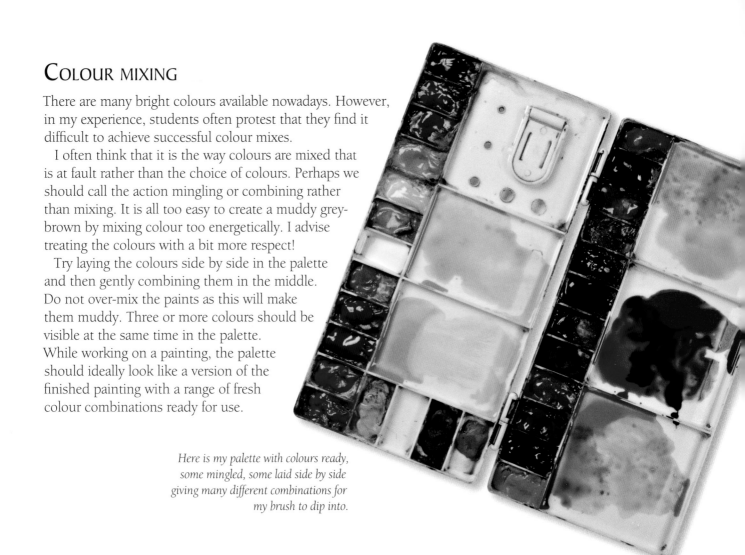

Here is my palette with colours ready, some mingled, some laid side by side giving many different combinations for my brush to dip into.

These illustrations of three colours loosely combined show how many different shades you can produce if you do not over-mix.

Raw sienna, permanent rose and French ultramarine
This gives several possibilities for colours within stonework.

Aureolin, transparent yellow and raw sienna
This gives a nice range of shades for clean, bright looking daffodils.

Hooker's green dark, Winsor blue and burnt sienna

In this combination there are several clean foliage colours for winter greens.

Phthalo turquoise, perylene maroon and quinacridone gold

Here we have clean non-muddy darks, ideal for backgrounds and shaded areas among massed leaves.

French ultramarine, burnt sienna and raw sienna

These three colours, in various ratios, will render tree trunks and twigs.

Winsor blue, Winsor violet and permanent rose

This gives a range of possibilities for bluebells and for flower backgrounds.

Hooker's green dark, burnt sienna and aureolin

Look carefully at this to find many different shades of green.

Cobalt blue, permanent rose and a touch of aureolin

This is a good combination for delicate translucent shadows on white flowers and within cloud formations.

Getting started

In these pages I cover some of the techniques which I use in most of my paintings. Working through it will give you a chance to try out these different techniques on a fairly simple subject.

I usually lay a first wash over wetted paper to begin. I may have masked out part or all of the main subject with masking fluid to protect it from this first wash and to ensure that there will be plenty of light areas in the final painting. I explain about masking fluid in more detail on page 22.

People often find it difficult to put a background in after they have finished the main subject, particularly with flower painting. I avoid this by starting with the background and tackling it head on! It then becomes part of the painting from the start. The background is integral to painting daffodils growing against a wall, so this is a good place to start our journey.

COMBINING PHOTOGRAPHS IN YOUR COMPOSITIONS

Nowadays digital photography is becoming an acceptable tool for the learning watercolour artist to use. While photographs are not there to be copied slavishly, they can provide useful reference material to help us. Thus, with the help of these two photos chosen from a selection I had taken in a Cotswold village, I was able to take my time to work out a composition using elements from both.

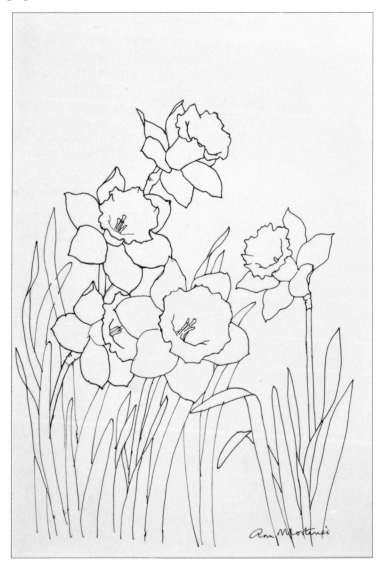

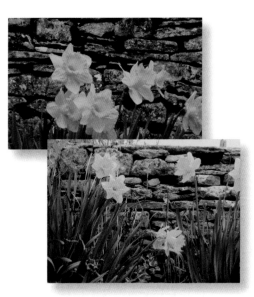

These source photographs show daffodils growing in front of a wall in a village in the Cotswolds.

This sketch combines individual flowers chosen from the photographs above and arranged into a more pleasing design for a painting. Notice that the central daffodil is slightly bigger than the others to serve as a focal point.

16

INITIAL SKETCHES

Sketching using nonpermanent felt marker pens is a good way of getting to know your flower subject and it is also good fun.

Using pen to explore the shape and form of the flower encourages you to be looser and more spontaneous. Because you cannot rub out your mistakes, you worry less about achieving a perfect result.

The ink flows when you touch it with a wet brush and so you can create shaded areas very easily and quickly. You can soon achieve a striking black and white image with lots of tonal contrast.

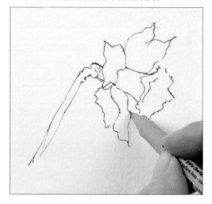 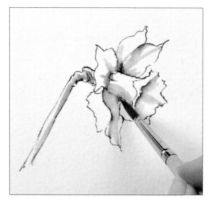 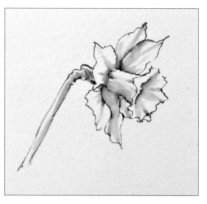

1 Using a fine-tipped nonpermanent black pen, sketch your flower on to the watercolour paper.

2 Wet your brush and put the tip to the ink lines. This draws the ink out, and you can use it to create tonal areas of the flower, adding shading to your picture.

3 Continue drawing the ink out, giving the flower form and depth. Make sure to leave some areas white to represent the lightest parts.

SETTING UP YOUR BOARD

I do not always stretch my paper, as I find that running masking tape around the entire sheet (as shown below) prevents it from cockling. It is very important to have all of your equipment ready in front of you before you start to paint. A watercolour wash will not be kept waiting!

My workspace, with everything set out ready to begin painting.

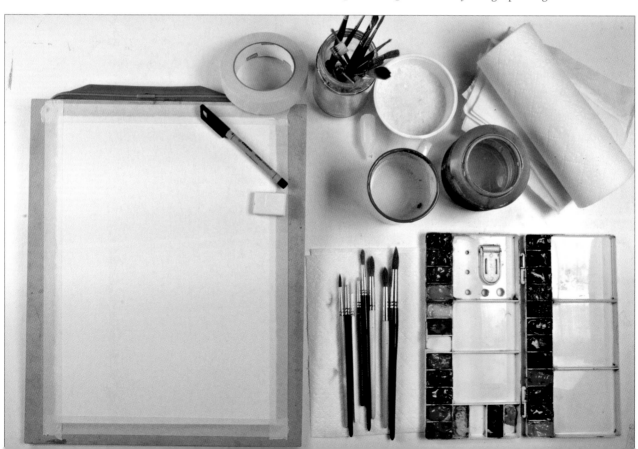

PENCIL SKETCH, MASKING AND WAX

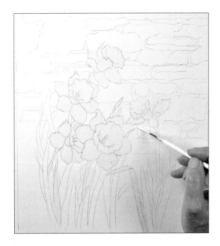

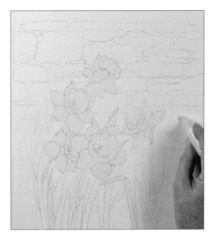

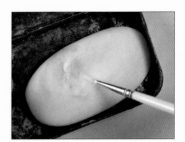

1 With your paper secured to the board, use a 2B pencil to sketch in the main areas of the painting. Use a nylon brush to apply masking fluid to the flowerheads and some stalks.

2 Continue applying masking fluid and allow to dry. Draw a candle over the top of the stones. It is important to work carefully and not overuse wax, as the highlights it creates are permanent.

INITIAL WASHES

When preparing my colours, I place the colours I wish to use in wells. I am careful to make sure than the colours bleed into one another a little in the centres of the wells, but that some of the pure colour remains at the edges. This gives me a great variety of colour, and prevents muddy, over-mixed paint.

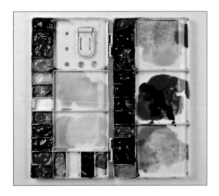

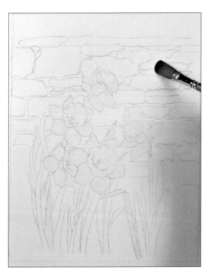

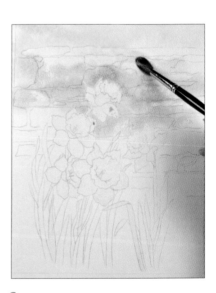

1 Use an old brush to prepare your wells. Place raw sienna and aureolin in one well for a daffodil mix; transparent yellow and aureolin in another for a variant daffodil mix; raw sienna, permanent rose and cobalt blue for a stone mix; French ultramarine, Winsor violet and burnt sienna for a dark mix; and Hooker's green dark, raw sienna and aureolin for a green mix.

2 Use a large brush to wet the paper with clean water. Allow this to soak in, then re-wet the paper.

3 Working from the top down, use the size 12 round brush to apply some cobalt blue to the sky area. Rinse the brush, and then use it to apply varied touches of the stone mix to the wall.

DEVELOPING THE PAINTING

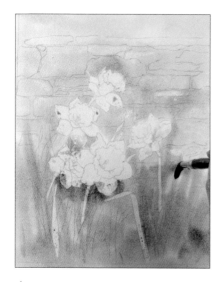

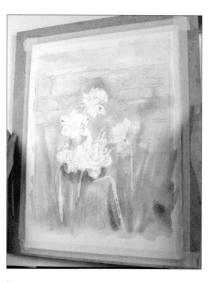

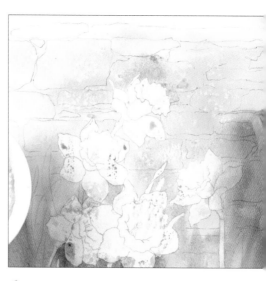

4 Rinse the brush again and apply the green mix around the bottom of the picture, allowing it to bleed into the wet stonework a little at the top. Drop in the yellows over the leaves and stems to show the light. Add a few touches of the dark mix below the daffodils and draw the colours upwards to create stems.

5 While the paint is still wet, pick up the board and gently tilt it back and forth to encourage the colours to merge.

6 Put the board back in place and sprinkle the wall area with salt to add texture. Allow it to dry thoroughly, then brush away the salt.

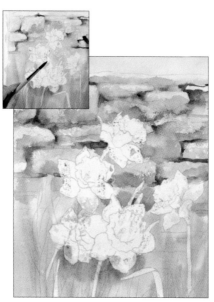

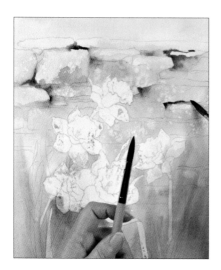

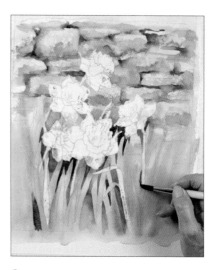

7 Use the size 10 brush to delineate the bricks in the wall with the dark mix.

TIP

I like to use two brushes at a time: one loaded with the paint, and one in the other hand, loaded with clean water and ready to blend the paint.

8 Continue to delineate the bricks, and introduce texture by drawing the side of a fairly dry brush over the stones (see inset). Aim for a variety of hues in the darks by dropping in touches of the other colours.

9 Use two size 10 rounds to apply the green and dark mixes to the lower half of the painting. Using French ultramarine and touches of the other colours in the dark well helps to keep the greens interesting. Use negative painting to make some of the stems jump forward as shown.

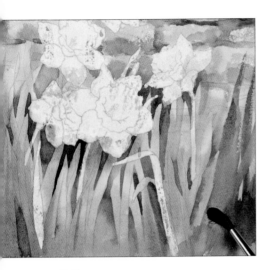

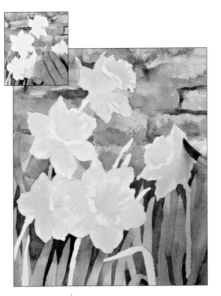

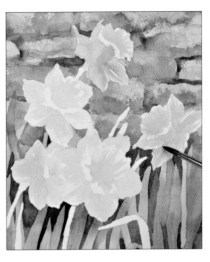

10 Still using the size 10 rounds, use the green mix with vertical strokes to add some dark leaves and stems on the edges of the painting. Work clean water into the bottom of the brushstrokes to soften them into the background.

11 Allow the paint to dry thoroughly, then use clean fingers to rub away the masking fluid (see inset), then use the size 10s to lay in a base of aureolin on the daffodils, leaving white spaces of clean paper for highlights.

12 Make a well of Indian yellow and permanent rose, then begin to model the daffodils using this new well with the other two yellow wells. Blend in touches of cobalt blue to add shading.

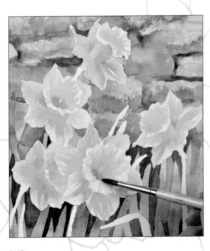

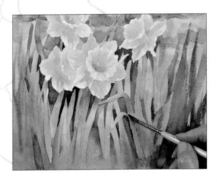

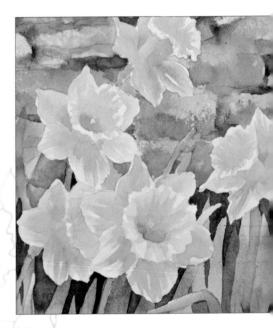

13 Continue to model the remaining flowers with the same colours, using stronger, warmer hues in the centres of the trumpets.

14 Lay in the daffodil mix to the stems and add touches of the green well wet-into-wet, letting the colours bleed into one another.

15 Use raw sienna on the calyxes (the papery cowls behind the flowerheads), then shade them by adding burnt sienna in wet-into-wet.

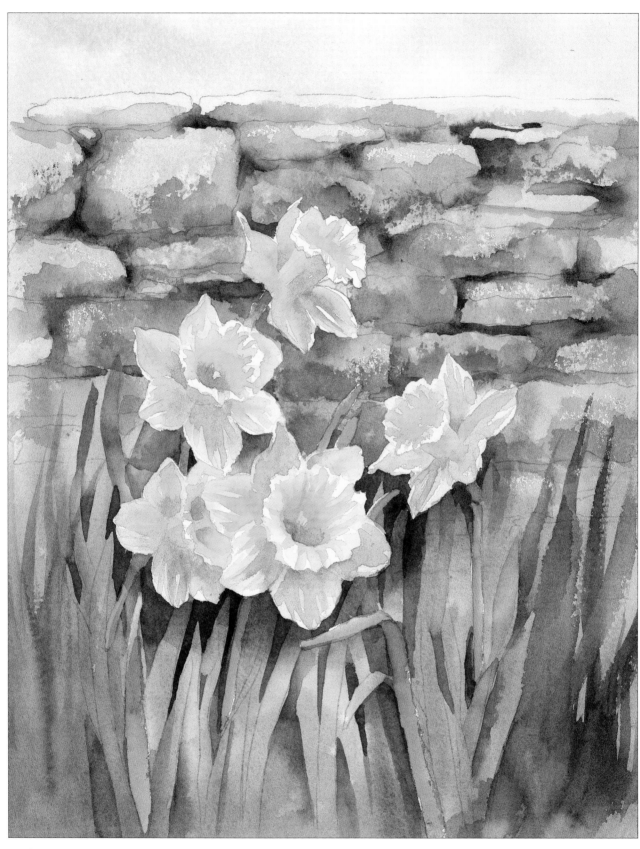

Daffodils and a Cotswold Wall
24 x 33cm (9½ x 13in)
Once dry, make any tweaks and additions that you feel are necessary.

USING MASKING FLUID

Masking fluid helps to create contrast by preserving areas of bright white paper and is an important part of the way I paint. Over the years, I have developed a trouble-free way of making sure it works – masking fluid without tears, if you like.

It is important to bear in mind that the fluid is a latex-based substance that can be difficult to remove from fabrics, so it does need to be used with care.

Useful tips for using masking fluid

In my experience, if you follow these guidelines, you can leave masking fluid on for days with no ill effects.

- Use a good brand of masking fluid. It needs to be liquid and easily spreadable, so do not use fluid that has been lurking in the back of a drawer for years.

- The shape that you create with the masking fluid is the shape you will be left with when you rub it off: a carefully painted leaf will look like a carefully painted leaf in the final picture. Equally, a misshapen splodge made with a stubby old brush clogged up with old masking fluid will look like a misshapen splodge when you rub the masking fluid off.

- It is important to use a brush with proper hairs. It can be an inexpensive synthetic one, but it must have a decent point. A size 2 or 3 is ideal.

- Coat your brush with soap before dipping it into the masking fluid and rinse it out immediately after use to keep it clean and usable.

- Colour shapers are convenient to use as they are easily cleaned by simply rubbing away the fluid. A size 1 is very good for fine lines, such as stamens on flowers.

- Put down a good layer of the fluid. The point of masking fluid is to isolate the part you do not want covered in paint, so a good thickness is essential. It is also easier to remove when laid quite thickly.

- Many painters say that the fluid can lift off and spoil the surface of the paper, which can completely ruin a painting. This will not happen if you make sure the paper is completely dry before use. Use the correct side of the paper (this is the one coated with more size).

- If you have dampened the paper in order to stretch it, then make sure there is no moisture left in it before applying masking fluid.

- Make sure everything is completely dry before rubbing off the masking fluid.

Snowdrops and Fallen Leaves
23 x 23cm (9 x 9in)
This picture of snowdrops shows how useful masking fluid can be in keeping areas clean and white, allowing you to paint pictures with striking contrast.

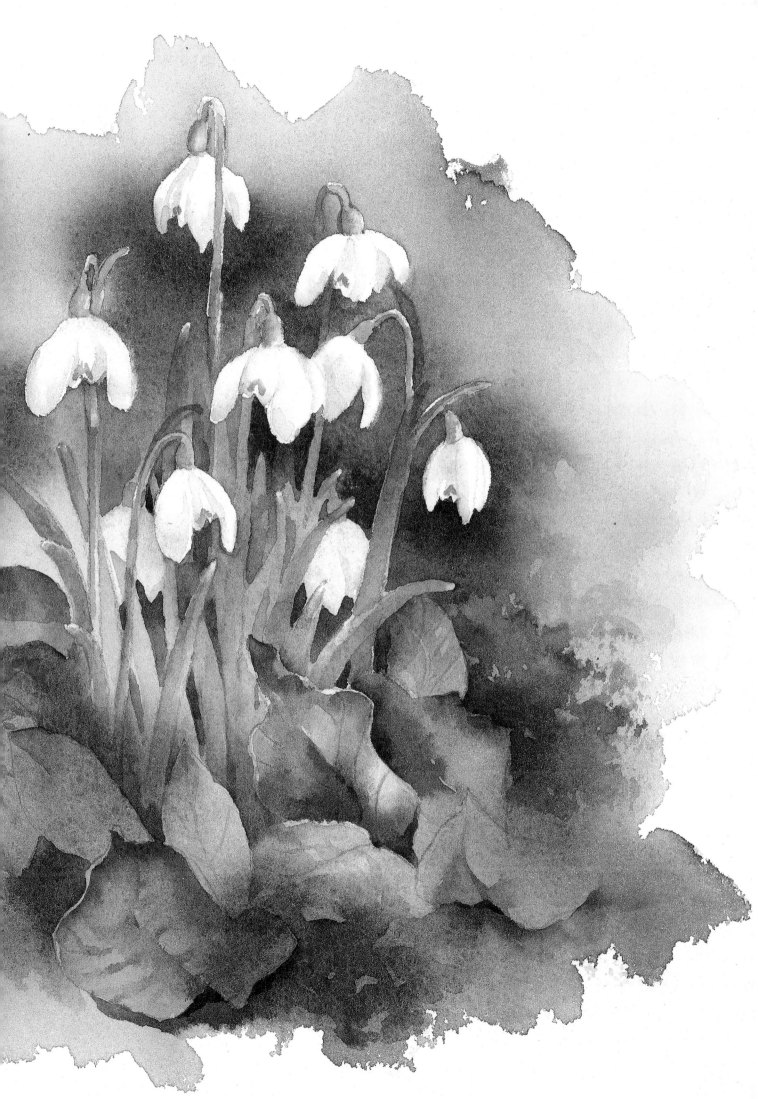

Choosing what to paint

DRAWING AND SCALING UP

Some compositions can be quite challenging to get right at the initial drawing stage. A good example is this scene of hollyhocks growing near the River Seine. There is a huge difference in scale between the flowers in the foreground and the barge and river in the background, and this gives plenty of scope for confusion.

With such a composition, I usually use a grid to make a preliminary sketch to get to know the layout. I drew a grid about the same size as the photograph on cartridge paper and overlaid the same size grid on the photograph using a piece of plastic film.

My initial drawing was more or less a contour sketch, feeling my way around the scene as I drew, relating each shape to another while using the grid for guidance.

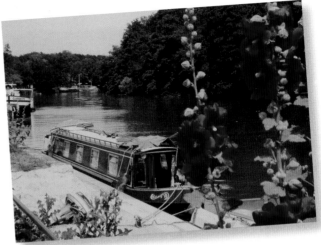

The original photograph

The initial sketch, showing the grid. This acts as a check on our assumptions about scale: the eye wants to have each thing the same size, but as you can see, the hollyhocks take up nearly half the space!

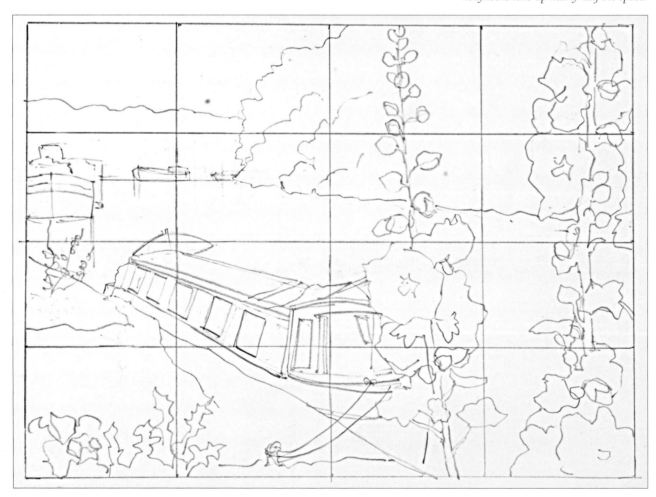

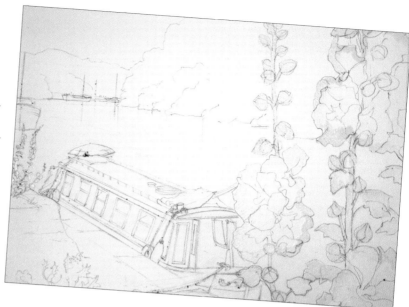

*After making the initial study, I scaled it up
on to watercolour paper, adding more detail.
Here is the sketch, showing masking fluid
applied, ready for painting.*

Riverside Hollyhocks

37 x 27cm (14½ x 10½in)

*During this particular summer in France, there seemed to be hollyhocks everywhere. I like
the surprising juxtaposition of the flowers and the river. The rich red hollyhocks stand out
against the complementary blue-green of the background.*

*To render the water, I first laid a wash in the same colours as the sky over it, then added
thick vertical strokes of yellows and greens wet-into-wet. As the paint dried, the colours
blended and merged on the paper.*

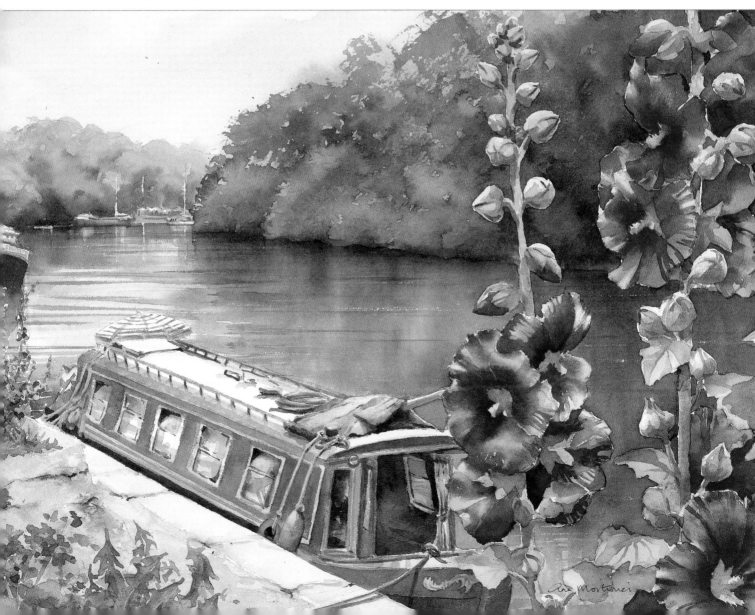

Perspective

Whatever the subject we are painting, perspective will always play a part, often without us realising it. Perspective is just as important in a painting of a vase of flowers as in one of a country road disappearing into the distance. This is because perspective deals in depth.

A sense of depth and of being drawn into a painting will always make it more pleasing and convincing. There are tricks and techniques we can employ to achieve this depth.

For our purposes here, we need to look at perspective in two main areas. These are **linear perspective**, for painting walls and buildings, and **aerial perspective**, for painting trees and flowers in the distance (see page 28).

You can draw or paint a scene without knowing the rules of perspective if you observe carefully. But having an idea of the rules can give you confidence and will provide a useful means by which to check the accuracy of your work.

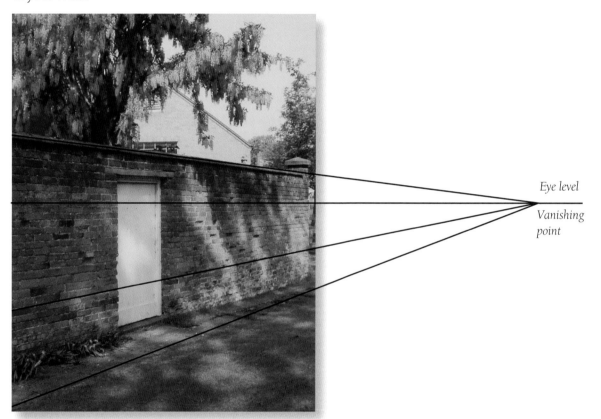

Eye level

Vanishing point

Linear perspective – walls and buildings

When we are out and about, the things that catch our eye as likely painting subjects often include buildings and walls at an angle. These features can act to lead the eye to the focal point of your picture.

In order to draw the wall and door above, the first step is to establish the **eye level**. You can do this by aligning a ruler with the bottom edge of the photo and then moving it up, stopping when you reach a horizontal line of mortar. When working on site, you can find the eye level by placing your hand flat and level with your eyes while looking at the scene in front of you.

Draw a soft line on your paper to mark this eye level. All horizontal features above this level – the door frame, the top of the wall, the lines of mortar – will slope down to this line and all the ones below it will slope up to it. If you draw lines through these features to the eye level (as shown above), they will all meet at the same place. This is called the **vanishing point**.

Once you have found the vanishing point, you can make sure that all the horizontal lines converge here and your wall or building will look correct.

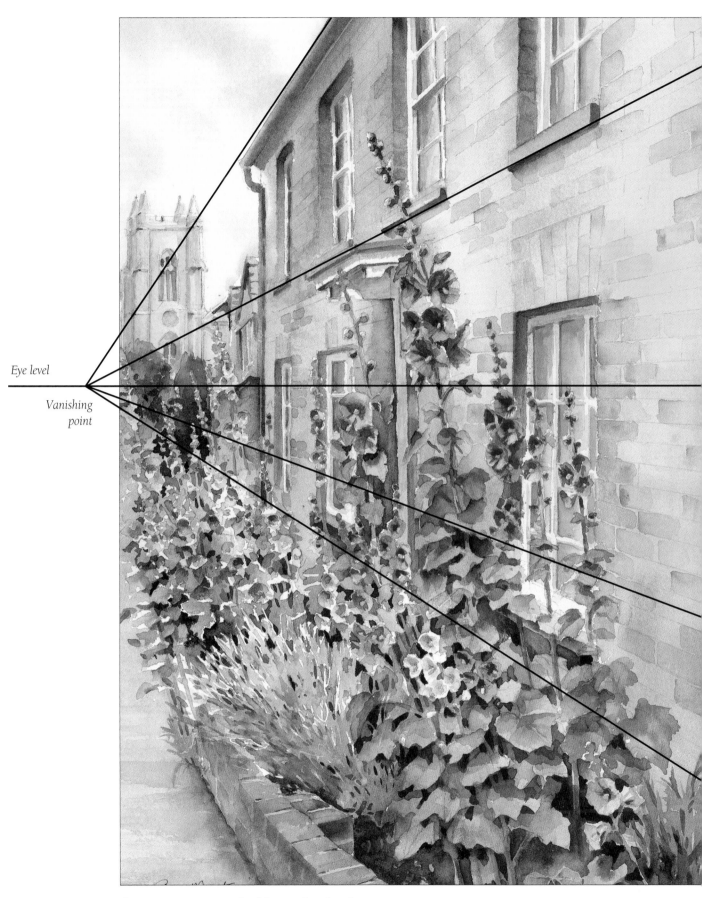

Eye level

Vanishing
point

*This painting is an example of the way the rules of
perspective can help us to produce an accurate drawing.*

Aerial perspective – trees and flowers

Imagine that you are standing at the edge of a bluebell wood in May. The flowers nestled under the tree next to you will be plain to see in all their detail; the separate tiny bells hanging down from the long, arched blue-green stalks. As you lift your eyes to view the whole scene, however, the bluebells in the distance will appear as a solid mass of lilac blue and single flowers and stalks will be indistinguishable.

This is a good example of how aerial perspective comes into play when painting flowers in the landscape. The flowers in the foreground need to be larger and more detailed. Those in the distance will have much less detail. So these need to be summarised by picking out essential features like their colour and growth habit. Treating the flowers in this way will bring a sense of depth to a painting.

It is helpful to observe the growth habits and essential features of the different flowers in order to be able to portray them convincingly in the middle ground or far distance. Try looking at the scene through half-closed eyes and paint the impression you have gained. This will look much more convincing than if you try to do portraits of the flowers.

Flowers in the foreground need to be quite detailed, as in a flower portrait. In the middle distance you need to summarise the essential features. So for instance with the bluebells in this picture, it is their colour, their arching stems and long arching leaves which identify them as bluebells. In the far distance, you need only give an impression of their colour en masse. Less detail helps to evoke a greater sense of depth.

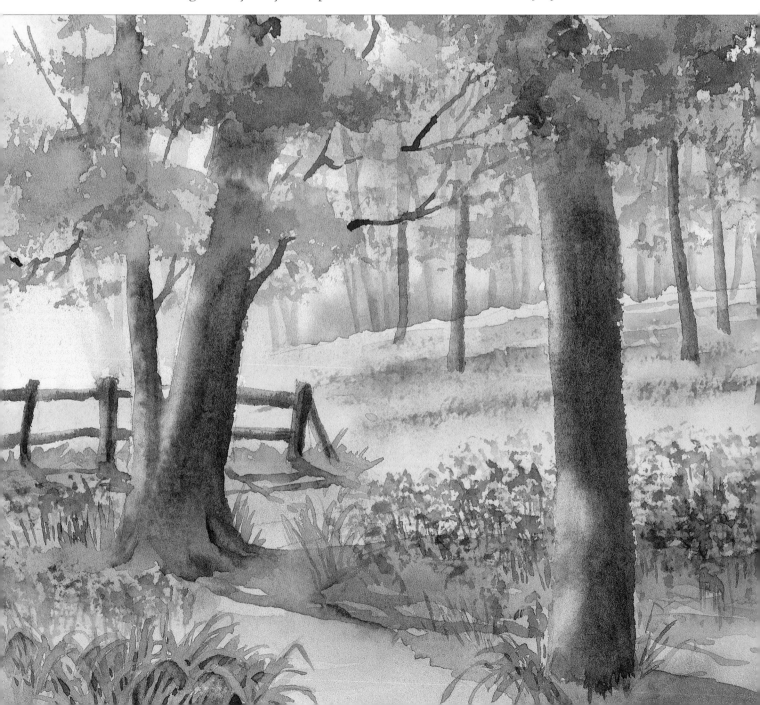

Geraniums have separate little florets within the flower heads. The individual florets catch the light and create various tones of light and dark within the flower heads. Paint them wet-into-wet in order to show these variegations. The leaves grow in horizontal layers and overlap one another.

Daffodils grow in clumps. They are tall and the flowers are all at the same level above long, sometimes arched, strap-like leaves. In the distance the flowers look star-shaped. Daffodils in the distance can seem little more than yellow dots hanging in mid-air; so that is what you need to paint.

TREES IN THE LANDSCAPE

You could write an entire book on the subject of painting trees, in fact many people have done just that! Here I have covered just a few aspects of painting trees in the landscape. These, along with the tips covered in the step-by-step projects, should help you to create convincing trees in your paintings.

Once again perspective comes into play when painting trees in the landscape. Trees in the foreground will be larger and will disappear out of the top of the painting. In the distance the same trees will be smaller so that you can see the whole of the tree and they will appear to be bluer and less detailed.

Foliage

When painting trees in a woodland setting, try painting the foliage first. For this you can use a dry brush technique. This works best on a rough surface watercolour paper. Mix up a good amount of quite thick paint and with your brush charged, dab off some of the paint on some kitchen paper or a rag and, holding the brush on its side, drag it across the paper.

As you drag it across, make the brush move up and down in a scrubbing motion and let the splayed hairs catch on the paper's textured surface.

While the paint is wet, you can gently drop in some darker tones wet-into-wet to give a variegated effect. Place several areas of foliage like this with gaps in between.

When this is dry you can add the tree trunks and branches. Work up from the ground and make areas of the trunk show through the holes which you will have created with the dry brush work.

Painting twigs with a rigger

A rigger brush can do more than paint rigging on a boat. It is perfect for twiggy trees.

In this illustration the rigger was used for the trunks as well as the twigs. For the trunk, hold the rigger on its side and loaded with plenty of paint, drag it up the paper. For the twigs, hold the rigger high up the handle and by varying the pressure of the brush hairs on the paper, you can make it dance about to create dynamic marks. If you press down slightly, and release, the brush will make the knobbly 'elbows' and 'knees' that are characteristic of twiggy branches.

The secret with a rigger is to practise first on a small piece of the same watercolour paper until you are happy with the marks you are making, and then turn to your painting. Try not to be too tidy!

Trees in the distance

You can give the illusion of trees in the distance by painting them more indistinctly using blues and violets. The further they are away the more water you will need to add to the mix. Or you can paint them wet-into-wet which will blur their edges and make them look mistier.

For this effect, lay a pale variegated wash with aureolin, cobalt blue and violet. Paint the tree trunks into this wet-into-wet, using a strong mix of cobalt blue, violet, and burnt sienna. This creates a misty atmosphere that will convey a sense of depth when combined with larger, warmer-coloured trees in the foreground.

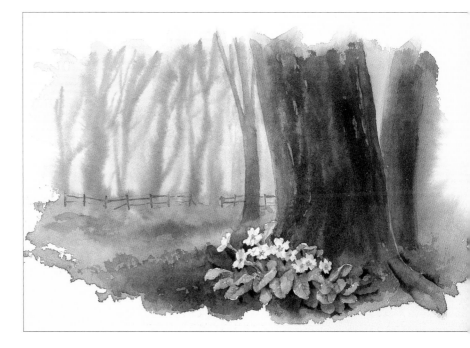

COTTAGES AT BIBURY

This beautiful row of cottages in a Cotswold village with the stream in front and the daffodils growing along its bank seemed to be a ready-made subject when I saw it. The old cottages in their preserved perfection were a good enough reason for me to want to paint the scene, but the stream and the daffodils combined with them to make a great composition.

The light that is reflected from the sky in the foreground stream attracts the eye which then follows the path of the stream into the picture. The shadow cast by the end cottage then sends the eye left to come back round via the daffodils to again rest and linger upon the stream in the foreground. Thus there is a simple composition which provides a journey round the painting. There is little that detracts the eye from its journey.

A composition should have a focal point as well as a way for the eye to find its way to it. When choosing a subject, you have to decide whether you have these things in place. If you do not, then choose another subject or try to edit and simplify the scene until you do.

It is essential to simplify compositions. That way the message that a painting conveys is clear and will have more impact. It is difficult to convince ourselves that we do not need to put every single detail into a scene we have chosen to paint.

Keep asking questions. Is this necessary? Do I really need to include this? Will this detract from the main message? In what ways can I summarise and simplify?

Nobody is going to check your reference material or your memory of the scene to see if it contains every detail. So take charge and have the confidence to make it your painting and your message.

Cottages at Bibury
37 x 27cm (14½ x 10½in)
The stream and line of cottages lead your eye into the scene. The light area and cast shadow at the end of the row have an important role in stopping the eye and taking it back into the picture.

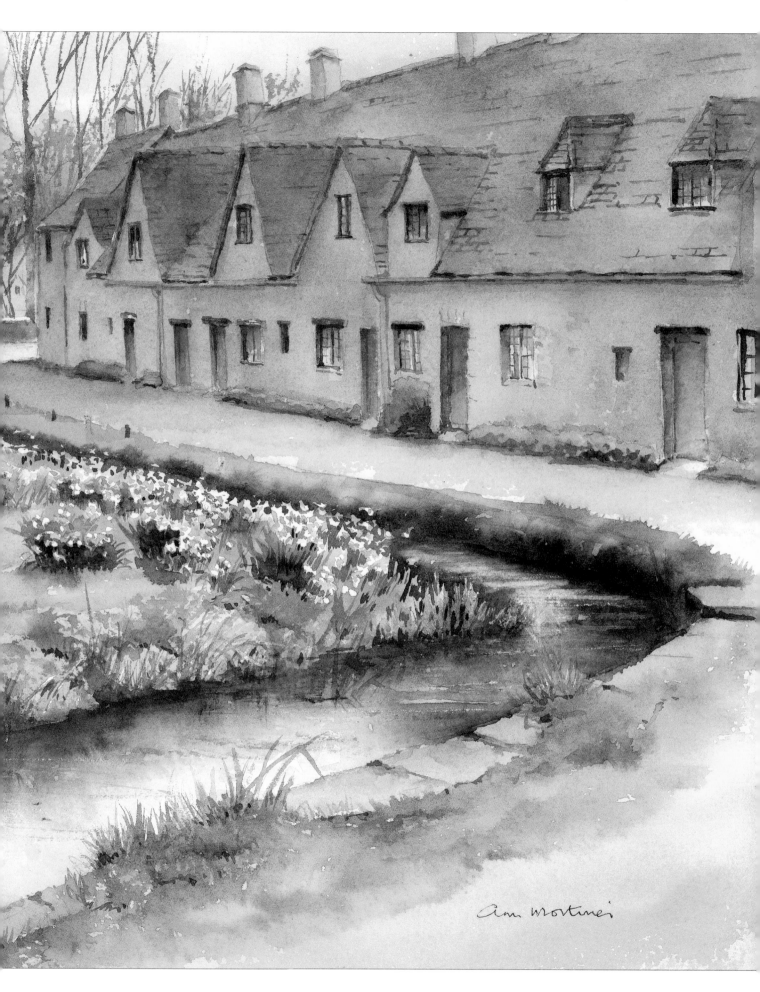

TERRACE AT PAUNAT

Your best paintings will always be the ones of subjects that have really inspired you. It might be the memories and feelings evoked by a scene, the challenges that it presents, the combination of colours or the play of lights and darks.

In this scene, of a breakfast terrace at a small hotel where we stay in France, I was attracted by the light and shadows and the sunlight shining down on to the table from above. I was excited by the possibilities for intense tonal contrast afforded by the foliage catching the light against the very dark backdrop. I wanted to see if I could capture the shadows on the paving and make the sunlit leaves stand out against the dark background

The focal point is the table and chairs and the play of light on them, so I carefully drew them out. They had to look convincing, being the focus of the painting. I masked them out carefully. I then laid a first wash of yellows and blues and greens, keeping the colours light and bright and leaving lots of white paper which would represent the leaves catching the light.

The foliage areas were painted using negative painting. I formed the leaf shapes out of the first wash by painting round them with strong dark mixes. The vine leaves were treated in the same way, painting the negative shapes between the leaves with strong mixes of blues, greens and reds to make them stand out in a 3D effect.

I have made the most of the opportunities for contrast by placing the white chairs in front of a dark leafy area and by placing dark leaf shapes against the sunlit paving in the foreground.

Opposite
Terrace at Paunat
35 x 26cm (14 x 10in)
There is a strong play of lights and darks in this painting. Hardly any of the leaves were painted as such. Instead, they were 'cut out' of a light first wash by painting dark tones around them.

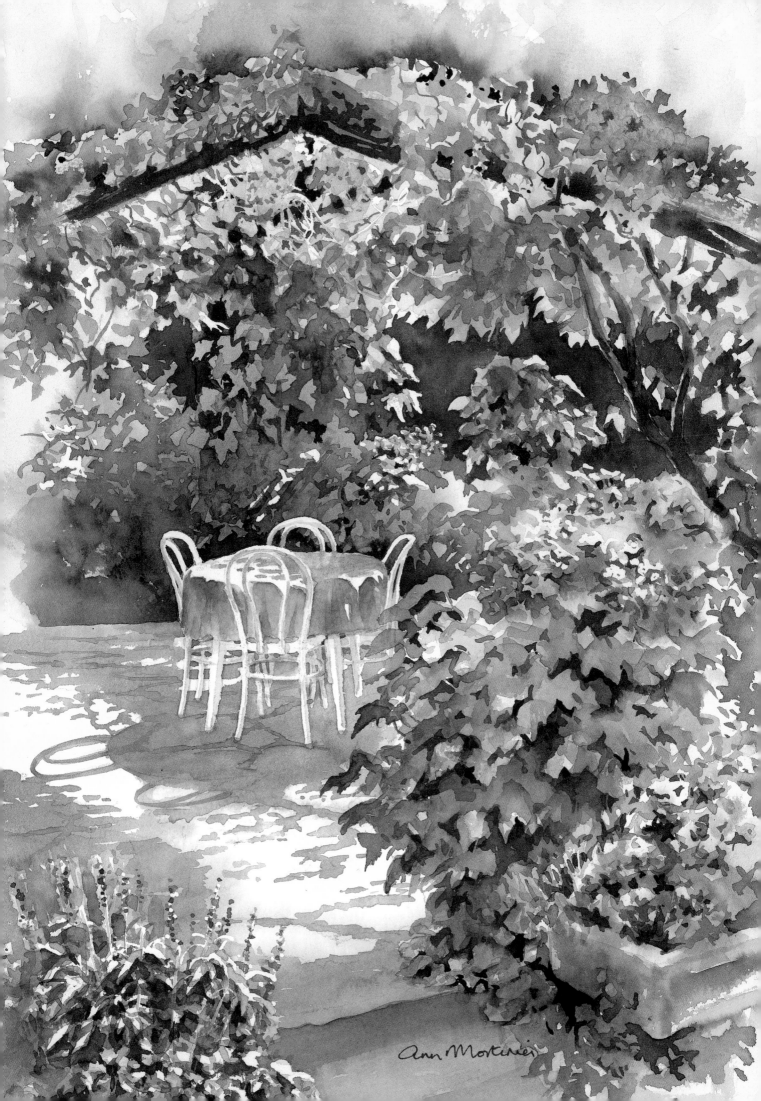

Ann Mortimer

Bluebell Wood

A wood filled with bluebells is a very special and fleeting example of flowers in the landscape. Although it is impossible to fully capture the atmosphere, scents and breathtakingly beautiful colours of bluebells growing en masse, we cannot be blamed for trying! Watercolour, with its delicacy and translucency is such an appropriate medium to use.

Keeping the blues and violets and pinks clean and fresh will be the main challenge in this project. The bluebells grow amongst green foliage and we know from basic colour theory that pinks/purples and green mixed together can make a sombre grey. So we have to be wary of letting these colours mix too readily on the paper.

Dappled sunshine is characteristic of spring woodland and in this project I try to retain the light in the painting by keeping the first washes fresh and not painting over them too much.

A lightness of touch is necessary for the trees and spring foliage too. The secret is to leave gaps in the foliage as you drag your brush across the paper. You can then weave your tree trunks and twigs in and out of the gaps for a natural effect. So let's get started!

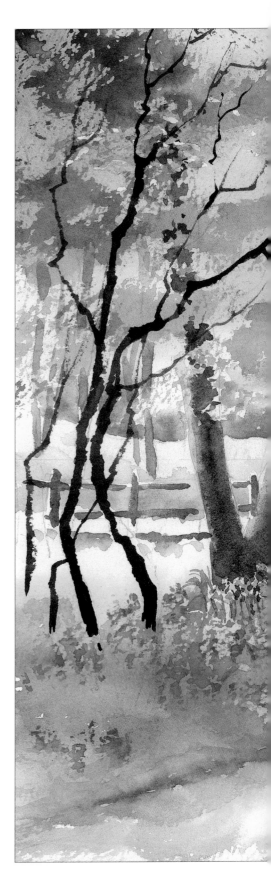

Here I found a ready-made composition using the camera's viewfinder. I especially like the way the path leads the eye to the sunlit area in the distance.

I drew this sketch to help me simplify the composition and understand the distribution of lights and darks.

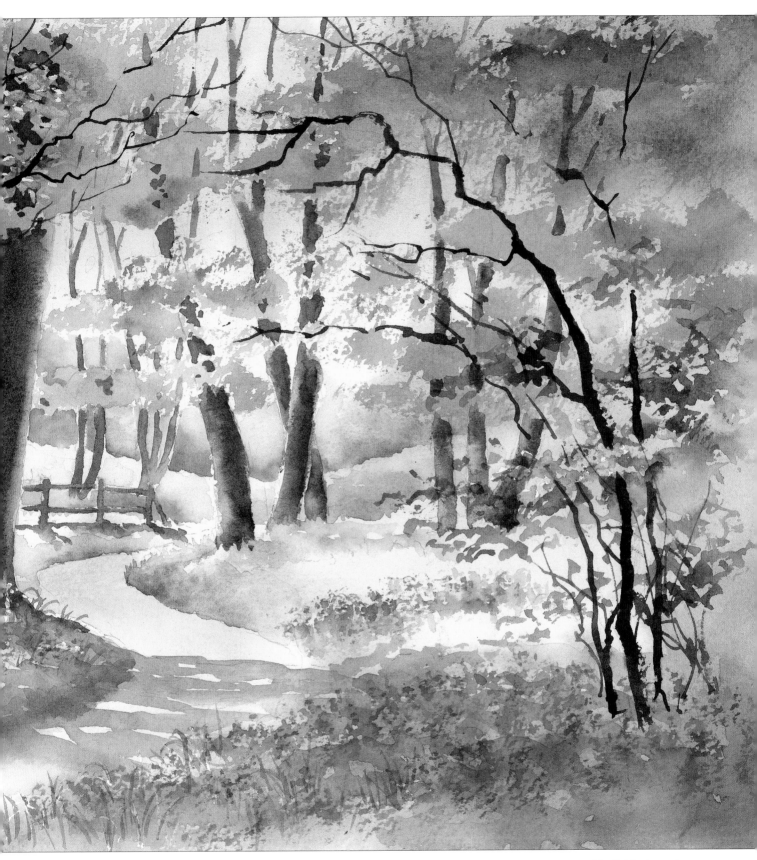

The finished painting.

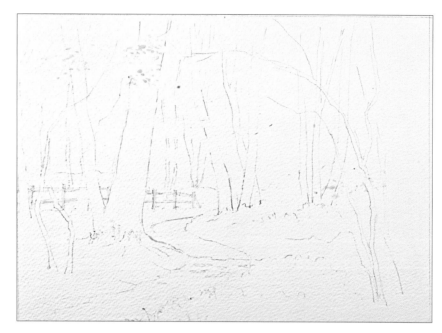

1 Sketch out the main shapes on the paper using a 2B pencil. Secure the paper to the board with masking tape, prop the board up and use the nylon size 3 round to apply masking fluid as shown. Prepare the following wells: a yellow well of raw sienna and aureolin; a dark well of French ultramarine, burnt sienna and Winsor violet; a blue well of cobalt blue, Winsor blue, Winsor violet, quinacridone magenta and permanent rose; a green well of Hooker's green, aureolin, French ultramarine and transparent yellow.

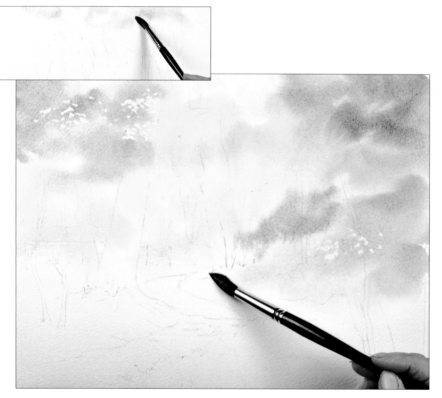

2 Wet the whole paper thoroughly with the 16mm (⅝in) filbert brush and clean water. Lay in the sky at the top with cobalt blue (see inset), then lay in the foliage at the top with the size 12 round using colours from the yellow and green wells to create a variegated wash.

TIP

It is important to keep the blues and violets clean, so use a large area separate from the other colours. A white dinner plate works very well!

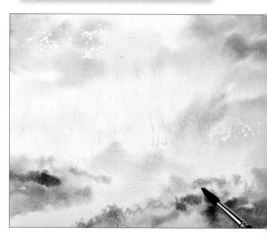

3 Continue laying in the variegated wash, introducing the colours from the blue well over the bluebells, and using the dark and green wells to lay in the foliage. Keep the colours in the centre fairly dilute to suggest a light area that draws the eye along the path.

38

4 Allow the painting to dry. Using the colours from the green well with a size 10 round, dry brush the paint over the paper in the top right. Splay the brush by adding a little pressure to produce a broken leafy canopy effect.

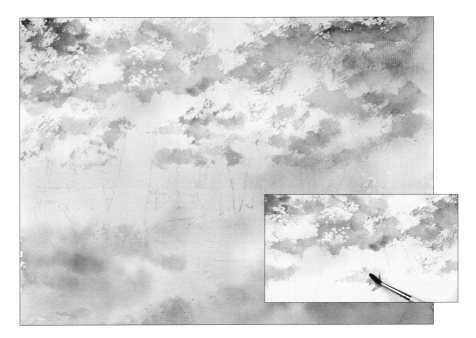

5 Continue this over the rest of the foliage area, remembering to keep the dark tones towards the sides and lighter tones in the centre. Swap to a size 6 round for the distant foliage (see inset).

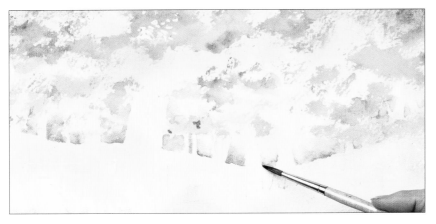

6 Switch to two size 10 round brushes, one for clean water and one for paint. Using French ultramarine and the darker colours from the green well, fill in the dark background between the trees and beneath the canopy. Wet each area, then drop in the colour and blend it away.

7 Using a size 10 round, lay in a raw sienna wash on the trunk of the largest tree.

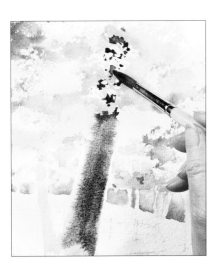

8 Working wet-into-wet, add colours from the dark well to the trunks and draw them up into the foliage. Use the tip of the brush to bring out the shape of the leaves with negative painting.

9 Paint the nearby tree in the same way, then bring out the bluebells at the base of the trees with negative painting, and suggest the root structures to finish this stage of the trees.

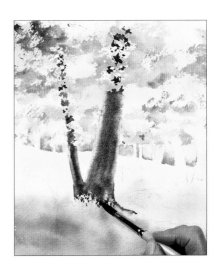

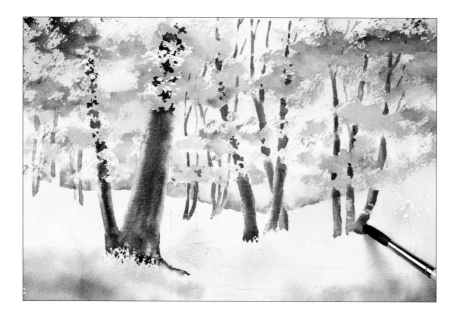

10 Paint the other background trees in the same way, using more dilute mixes for the more distant trees. Paint with a broken, hit-and-miss action to give the impression the foliage is in front of the branches.

11 Using the colours from the green well and a little burnt sienna, paint in a layer of dark across the middle of the painting. Blend it away upwards using clean water. This gives a sense of distance and brings out the fence.

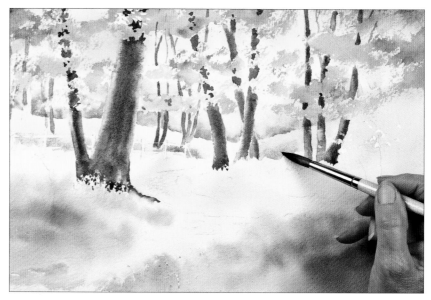

12 Using the blue well, draw a dry size 10 round across the bluebell areas with short strokes of the side of the brush. Keep the brush moving and vary the colours as you work. With the help of the paper's texture, the marks you make will look like separate bluebell flowers.

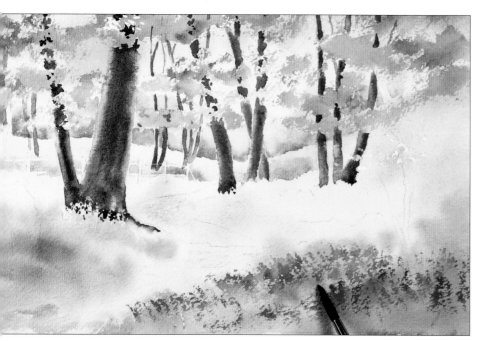

TIP

Draw the loaded brush over some kitchen paper to draw out excess moisture. This helps you with the dry brush technique.

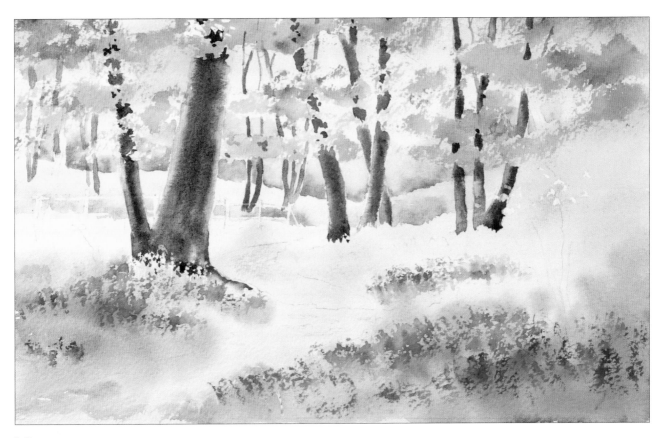

13 Change to the size 6 round brushes for the distant bluebells, and continue until all of the bluebells are painted.

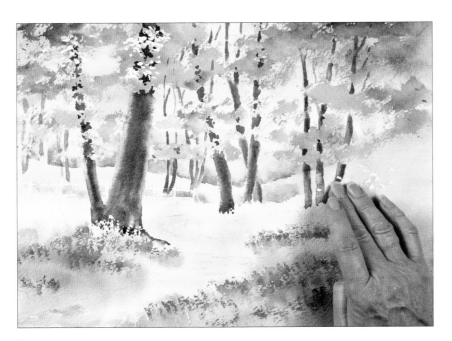

14 Allow the entire painting to dry thoroughly, then use a clean finger to remove all of the masking fluid.

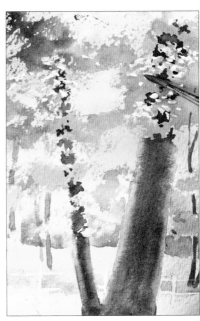

15 Using the size 6 round brushes, paint in the unmasked leaves in the canopy using aureolin.

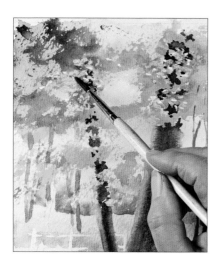

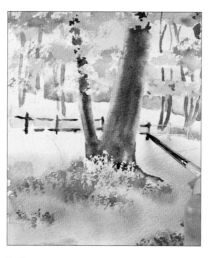

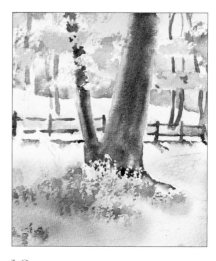

16 Working wet-into-wet, add tonal variation with the colours from the green well.

17 Still using the size 6 brushes, paint the fence with colours from the dark well dropped into raw sienna.

18 Add a little French ultramarine wet-into-wet to suggest shading on the fence.

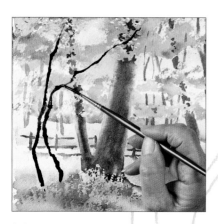

19 Mix up a large quantity of burnt sienna and French ultramarine, then use the side of a size 3 rigger to paint in the main shapes of the tree on the left of the foreground.

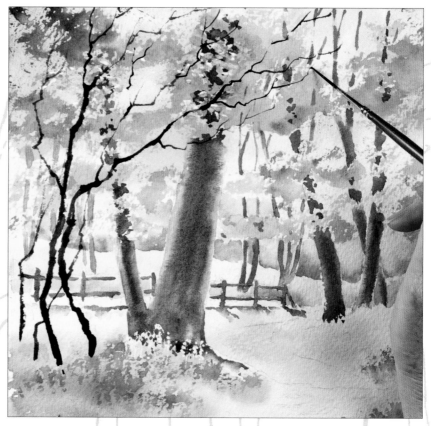

20 Switch to a size 1 rigger to paint smaller branches and twigs on to the tree.

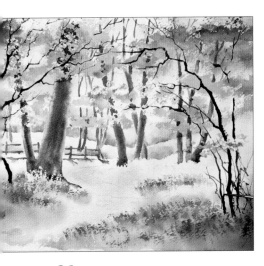 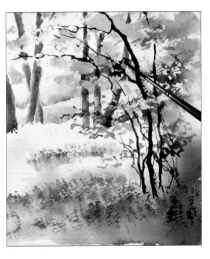

21 Paint the right-hand tree in the same way, adding some smaller saplings at the base.

22 Using bright, strong colours from the green well, add leaves to the right-hand tree with the size 3 rigger.

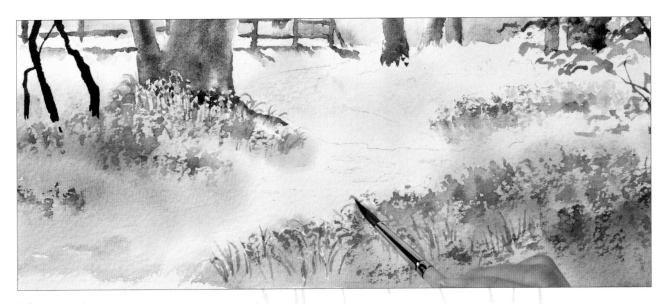

23 Use a size 6 round and colours from the blue well to lay some colour on the unmasked bluebells.

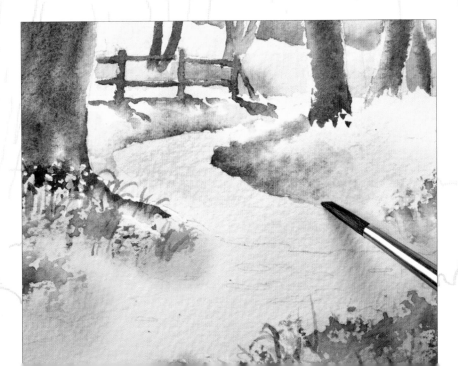

24 Wet the grassy banks on either side of the path with clean water, and drop in various colours from the green well to give you a variegated effect.

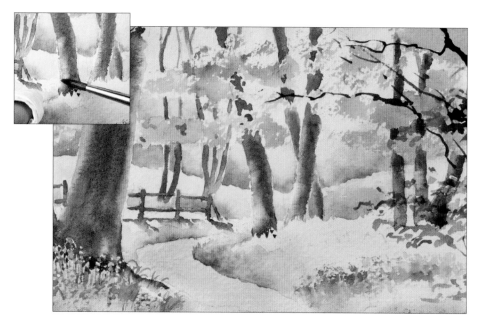

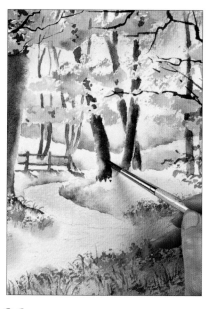

25 Wet your size 6 round and use it to agitate the paint on the left-hand side of the central group of trees. Dab the area gently with kitchen paper (see inset). This will lift out some of the paint and create a highlight to give the effect of dappled sunlight.

26 Wet the right-hand sides of the same group of trees and drop in a mix of French ultramarine and burnt sienna.

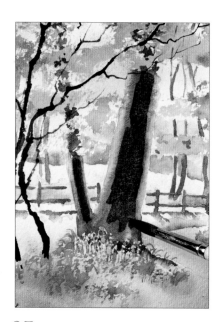

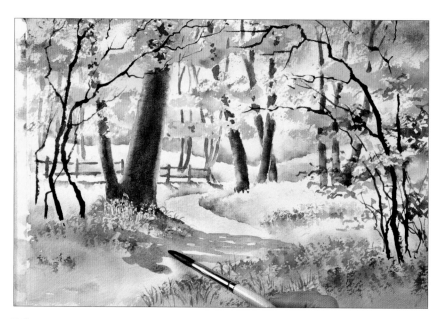

27 Make a shadow well of French ultramarine, burnt sienna and a little Winsor violet. Use a size 10 round brush to paint the side of the foreground tree.

28 Blend out the colour with a wet size 10 brush, drawing it across the tree and path.

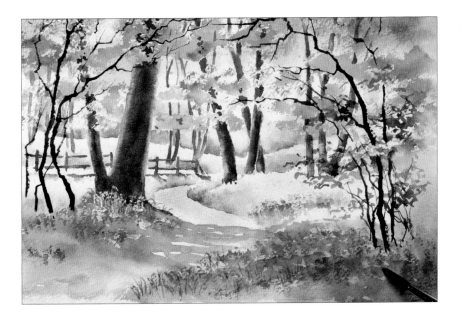

29 Using dilute colours from the shadow well with the size 10 round brushes, continue drawing the shadow across the whole foreground. Leave broken areas for dappled sunlight, and use a stronger tone in the lower right.

30 Add other hints of shadow to the background in the same way, using a size 6 brush. Allow the painting to dry.

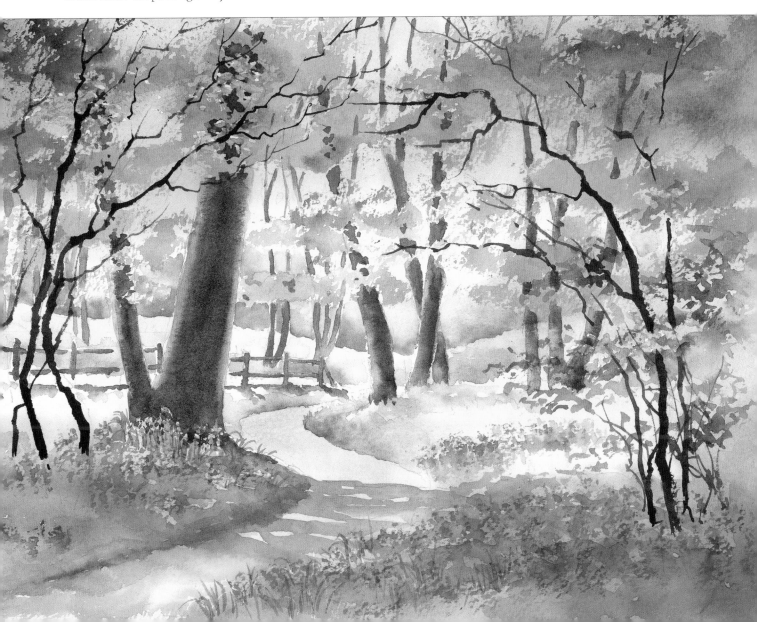

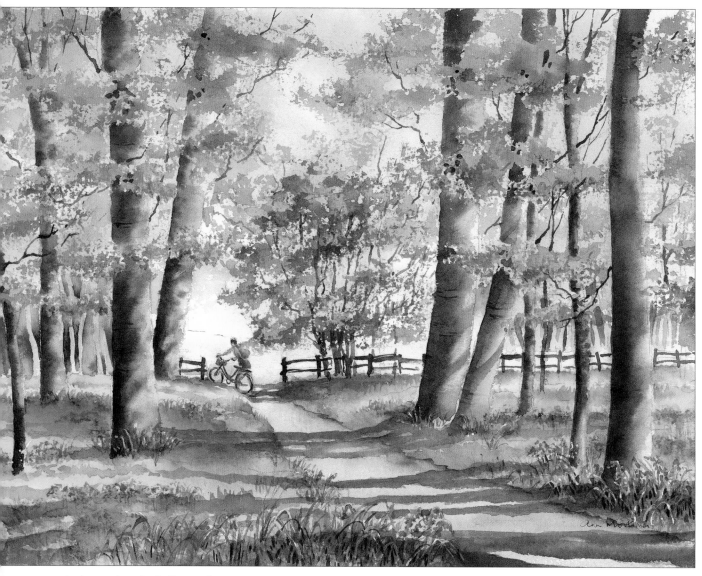

Cyclist in the Bluebell Woods

35 x 27cm (13½ x 10½in)

All of the familiar elements of a bluebell wood are here in this painting: the massed bluebells disappearing into clouds of misty blue, the tall trees, spring green foliage and dappled sunshine. The cyclist adds an element of narrative. Where has he come from? How long did he spend admiring this woodland scene before continuing on his journey?

Opposite

Bluebells in Bunny Wood

47 x 34cm (18½ x 13½in)

Here I have painted recognisable bluebells in the foreground. In the middle distance the flowers are little more than random shapes created with a dry brush on the rough surface paper. In the distance, they are simply a haze of blue. To add to the sense of depth it was important to make the trees in the distance a blue-violet colour and to leave an area of light at the end of the path.

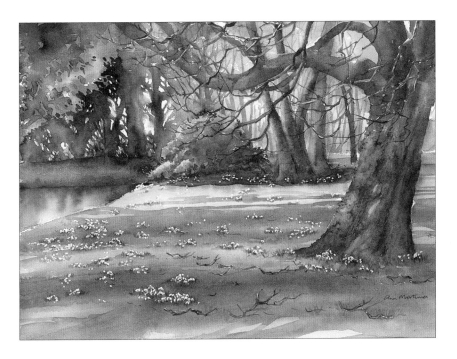

Snowdrops at Hodsock
37 x 27cm (14½ x 10½in)
In this scene I liked the snowdrops scattered about the grassy riverbank and the way the large tree provides a framework leading the eye to the small area of reflected light in the river. The snowdrops were masked out and then darker tones were added below them later on to make them sink into their grassy positions.

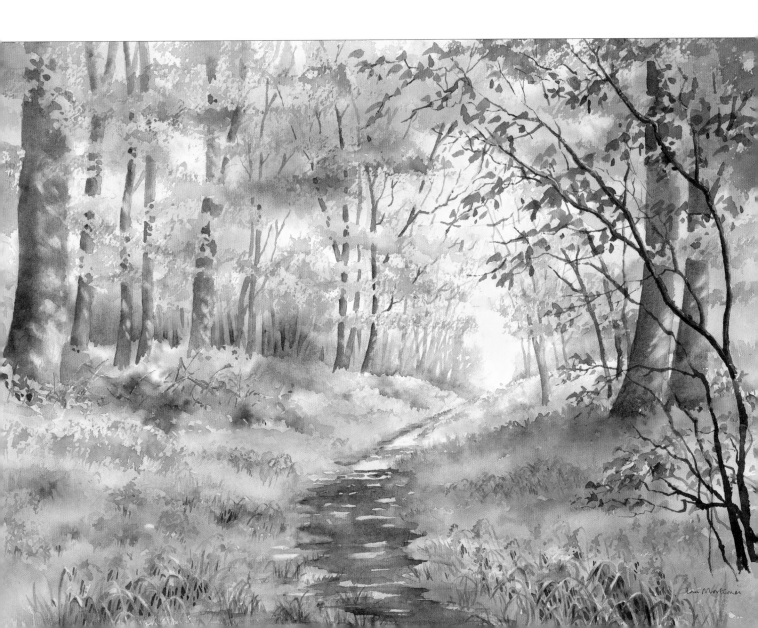

Letterbox and Hollyhock

I like subjects that give a hint of a human presence. This letterbox, attached to a fence outside a village house with the newly delivered mail visible, is just such a subject. I took photographs of the letterbox and a hollyhock flower nearby on the same day and thought of combining the two photos into a composition.

Sunshine is an important element in this painting. Cast shadows are one of my passions and the hollyhock is brought to life by the shadow in its centre. It gives it form and depth which is always a good start!

It is important when painting the ivy foliage in this subject, to retain the light and keep it looking sunlit. I did this by weaving darker tones around the ivy leaves so that the yellow areas of the first wash stay untouched and therefore bright and clean.

I took these photographs while walking through a village in France with the idea that they would make an interesting subject to paint. I was particularly attracted by the cast shadows on the main hollyhock flower.

I combined elements from the two photographs into a sketch to see if the composition would work.

Opposite
The finished painting.

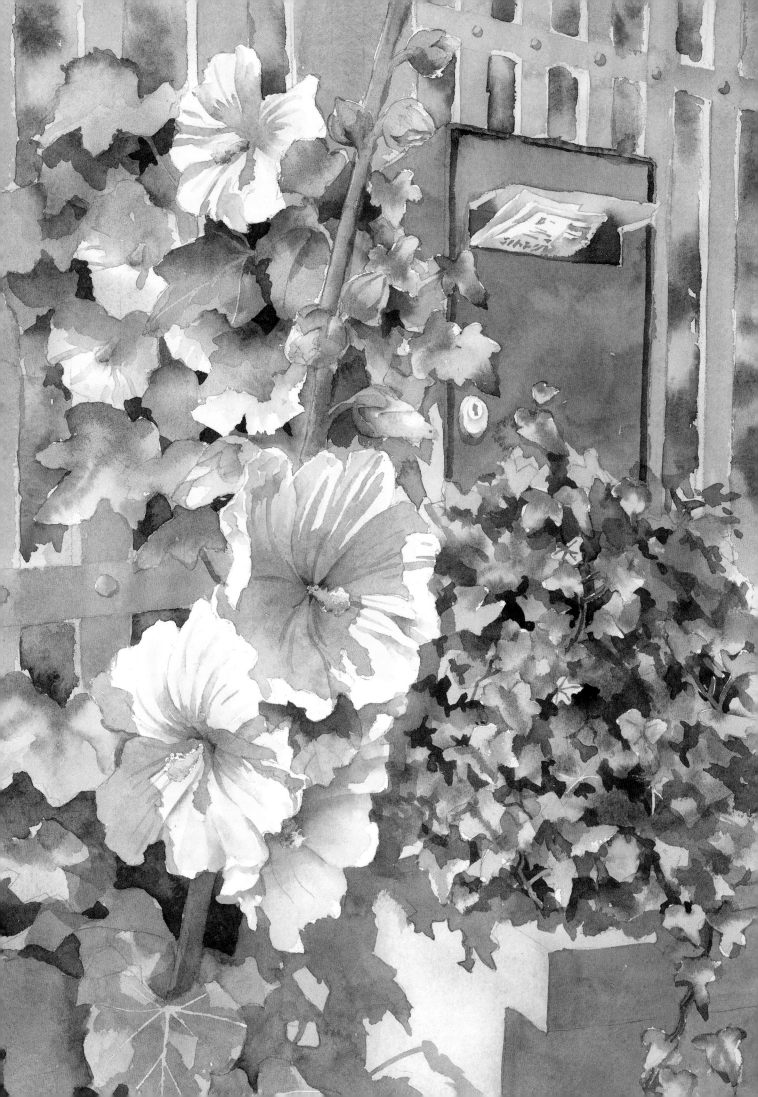

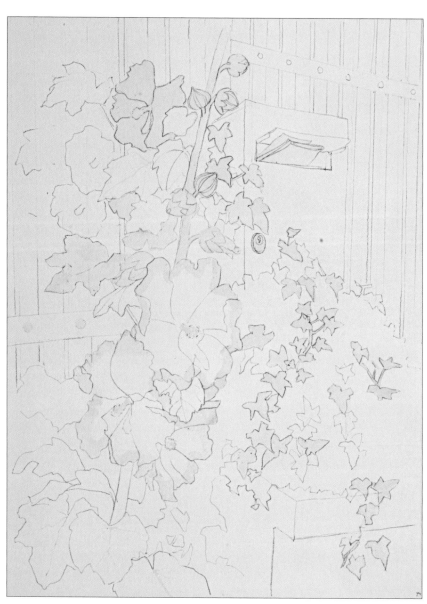

1 Sketch the main shape on to the
paper using a 2B pencil and apply
masking fluid as shown using a nylon
size 3 round. Secure the paper to a
board with masking tape and prop the
board up. Prepare the following wells: a
yellow well of aureolin and raw sienna;
a dark well of French ultramarine,
perylene maroon and phthalo
turquoise; a shadow well of cobalt blue
and a touch of permanent rose; and
a green well of Hooker's green dark,
aureolin and French ultramarine.

2 Wet the paper thoroughly with a
16mm (⅝in) filbert brush. Working
from the top, drop in cobalt blue and
colours from the yellow well using a
size 10 round.

3 Working wet-into-wet, bring in
phthalo turquoise over the letterbox.

4 Use the yellow and green wells
to add colour over the hollyhock
and ivy leaves. Drop dark greens
into the ivy area, making sure to
leave plenty of light areas.

5 Return to cobalt blue for the stonework, and add colours from the shadow well to mute it. Drop in a touch of raw sienna, then allow the painting to dry.

6 Wetting the areas first, use the size 6 brushes with the green well to create a variegated effect behind the railings, dropping in touches of permanent rose to suggest background roses.

TIP
Be careful to only wet the areas between the railings before dropping in the paint.

7 Using the size 10 round brushes with phthalo turquoise and a little perylene maroon, begin to add shading to the letterbox.

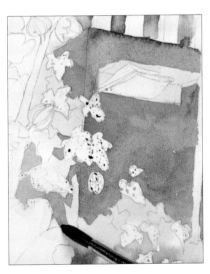

8 Continue with the same colour, bringing out the ivy leaves with negative painting, and leaving some areas of dappled sunlight on the side of the letterbox.

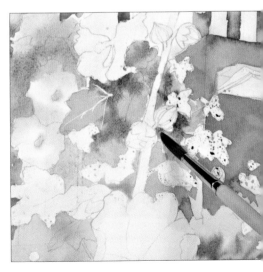

9 Use a dilute green mix to wash over the hollyhock and ivy leaves at the top, introducing darker greens wet-into-wet.

51

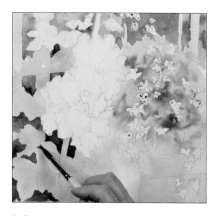

10 Using the green and dark wells, develop the hollyhock leaves at the bottom with negative painting.

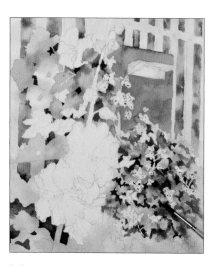

11 Using the size 6 brushes and the same colours, develop the hollyhock and ivy leaves at the top, then do the same to the mass of ivy on the right, bringing out the ivy leaf shapes with negative painting.

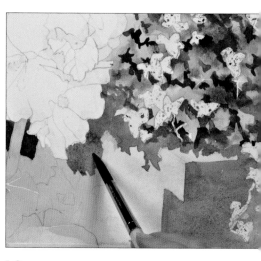

12 Use the size 10 to paint the shaded part of the wall using the shadow well (cobalt blue and permanent rose) with a touch of raw sienna. Extend the shadow beneath the hollyhock.

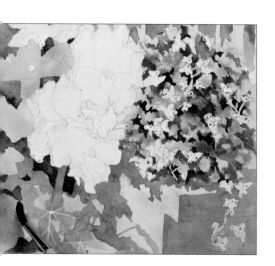

13 Continue developing areas of shadow across to the left.

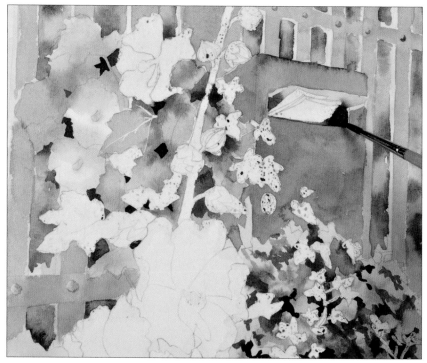

14 Remove the masking fluid from the studs and paint them with a more dilute shadow mix. Use the same mix for the front of the railings, and a stronger mix for the slot of the letterbox. Blend this strong mix upwards using a wet size 6.

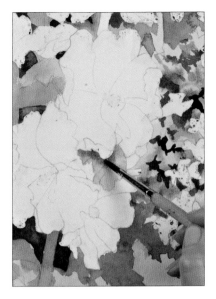

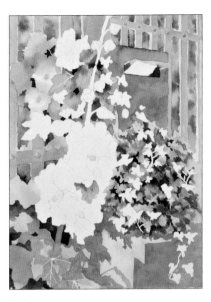

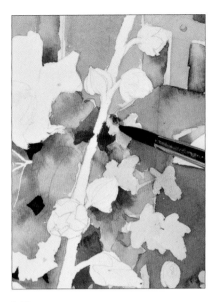

15 Fill in the leaf between the main flowers as for the hollyhock leaves (see step 10).

16 Allow the painting to dry, then use a clean finger to remove all of the masking fluid, except for the centres of the stamens.

17 Starting from the top, drop in aureolin to the ivy areas, then add darker colours wet-into-wet from the green well (Hooker's green dark, aureolin and French ultramarine) to vary the hues in the leaves.

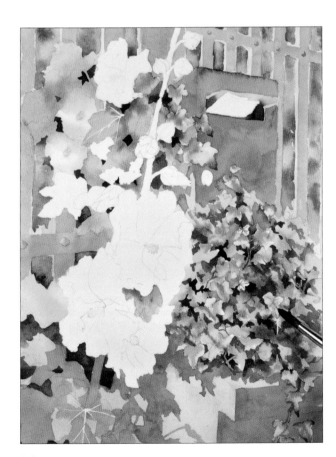

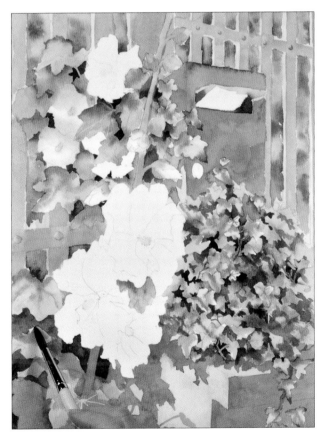

18 Continue painting the rest of the ivy, adding perylene maroon wet-into-wet for the ivy stems.

19 Paint the buds, leaves and stems on the hollyhocks with the same greens, but do not add perylene maroon.

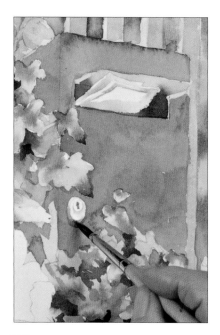

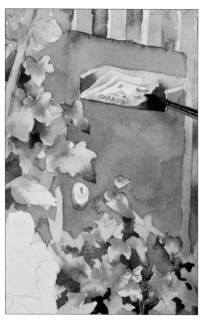

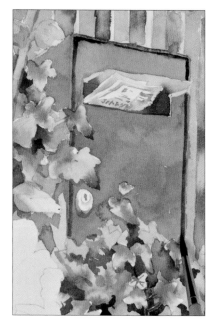

20 Using dilute mixes of the colours from the shadow well (cobalt blue and permanent rose), add some tone to the newspaper in the slot and the lock of the letterbox. Blend the colour outwards using a wet brush.

21 Using a stronger mix of the same colours, use the tip of the brush to suggest text on the envelopes.

22 Use a strong mix of phthalo turquoise and perylene maroon to detail the recesses on the front of the letterbox.

23 Wet the whole of the central hollyhock with clean water, and drop in aureolin to the centre of the top flower, pulling the paint outwards with short strokes.

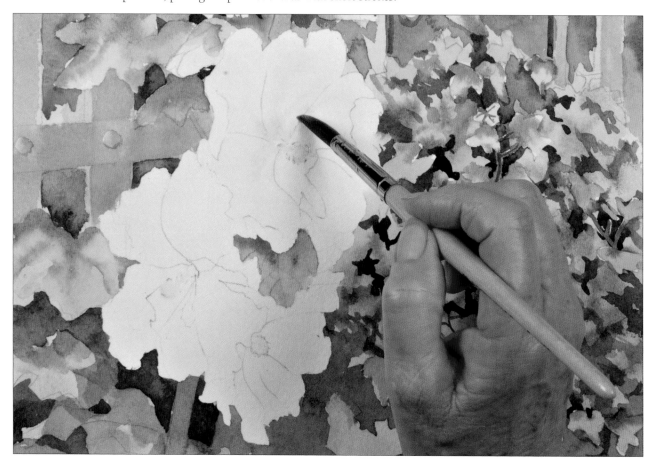

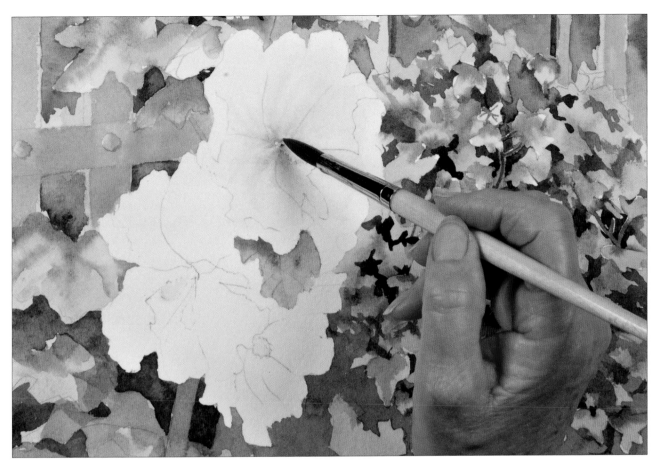

24 Make a dilute mix of Hooker's green dark with a touch of French ultramarine, and drop it in wet-into-wet, drawing it out from the flower centre along the petals.

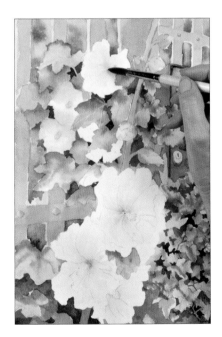

25 Paint the other main hollyhock flowers in the same way.

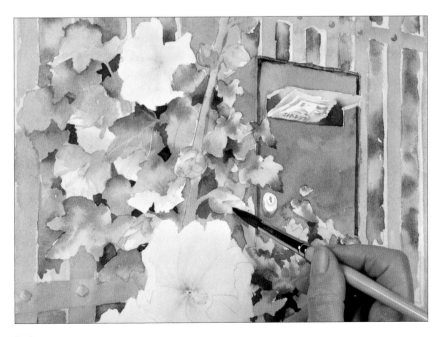

26 Use the shadow well to add modelling to the background hollyhocks and buds. Add a touch of permanent rose to the ends of the buds.

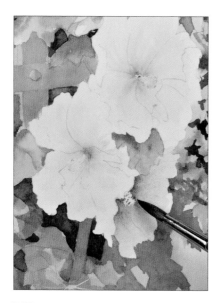

27 Use the same shadow mix on the lowest hollyhock. While the colour is still wet, add touches of permanent rose to warm it a little.

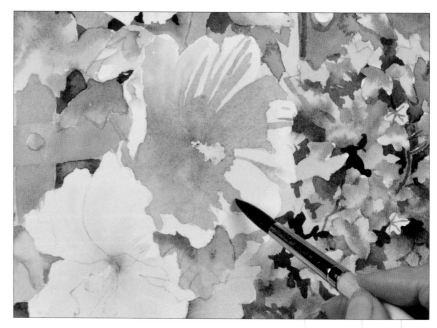

28 Paint the central hollyhock with the same colours, drawing the colour out from the centre to form the shading.

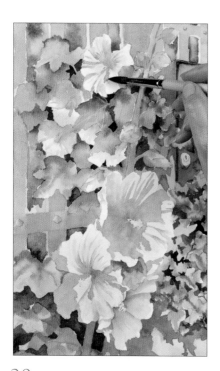

29 Shade the other main hollyhocks in the same way.

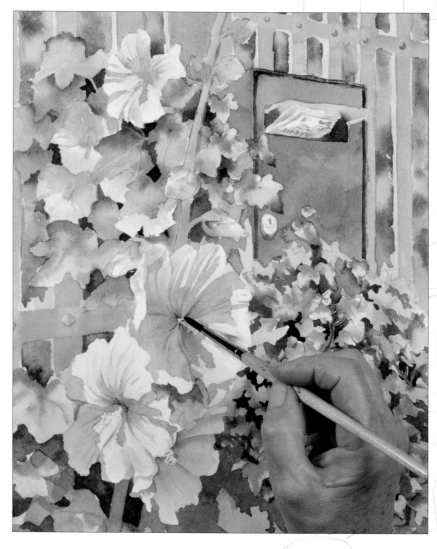

30 Once dry, return to each flower and reinforce the shadows with overlaid glazes.

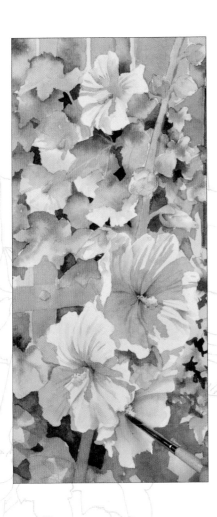

31 Remove the masking fluid from the stamens and use aureolin to paint them. Add some raw sienna to the shadow well colours and drop this in wet-into-wet for shading.

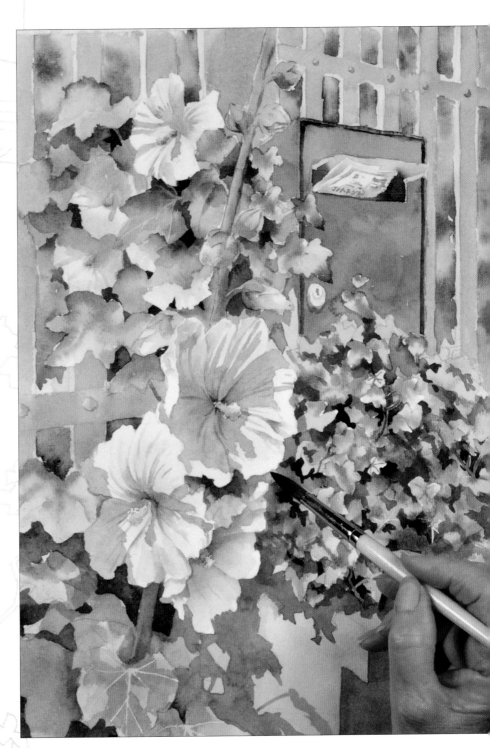

32 Strengthen the darker areas across the painting, using darker colours from the green well (Hooker's green dark, aureolin and French ultramarine) for the foliage and the shadow well for the rest of the picture. Allow to dry to finish.

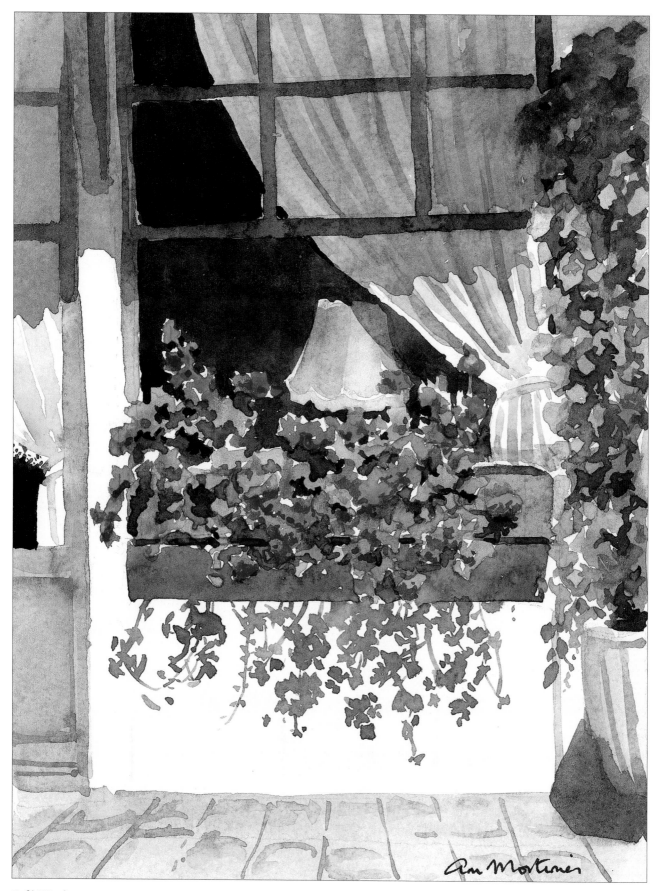

Café Window

14 x 19cm (5½ x 7½in)

The shadows cast by the pelagoniums in the windowbox form the focal point of this painting. It is the extreme contrast between the light and darks which makes this scene look sunny.

58

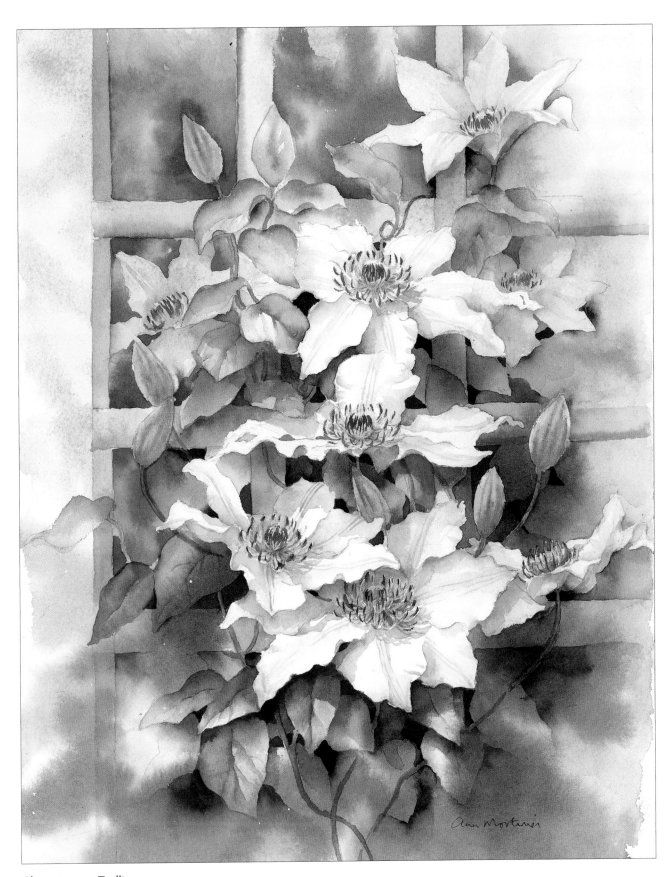

Clematis on a Trellis

24 x 34cm (9½ x 13½in)

A sense of depth was created by overlapping the flowers and leaves, and adding darker tones in the negative spaces between them. You can see where the first wash of yellow (aureolin) is still visible on the trellis and leaves at the back. This gives a feeling of sunshine over the flowers and leaves.

Daisies on a Table

I have painted this vase many times with different flowers in it. It is made from recycled green glass and I like the way the darkest areas of the green glass contrast with the light in the centre.

I noticed how the intense sunshine on this summer's day produced contrasting shadows in the garden, and so deliberately set up this composition, with white daisies and the outrageously dark shadow cast by the vase and flowers.

There is surprisingly little painting involved in this subject. The white flowers are mostly unpainted white paper and the table has only one layer of paint on it. It is a good example of how less is more in watercolour painting. By this I mean that we should aim to put the colour down once and then leave it alone. It is a mantra that my students are probably tired of hearing!

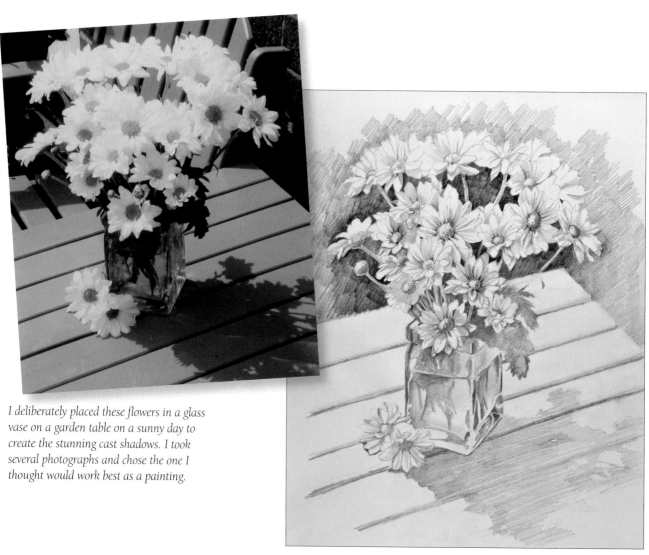

I deliberately placed these flowers in a glass vase on a garden table on a sunny day to create the stunning cast shadows. I took several photographs and chose the one I thought would work best as a painting.

Making a sketch of the photograph allowed me to understand how the flowers overlapped each other and to see how many of them were actually in shadow.

*Opposite
The finished painting.*

60

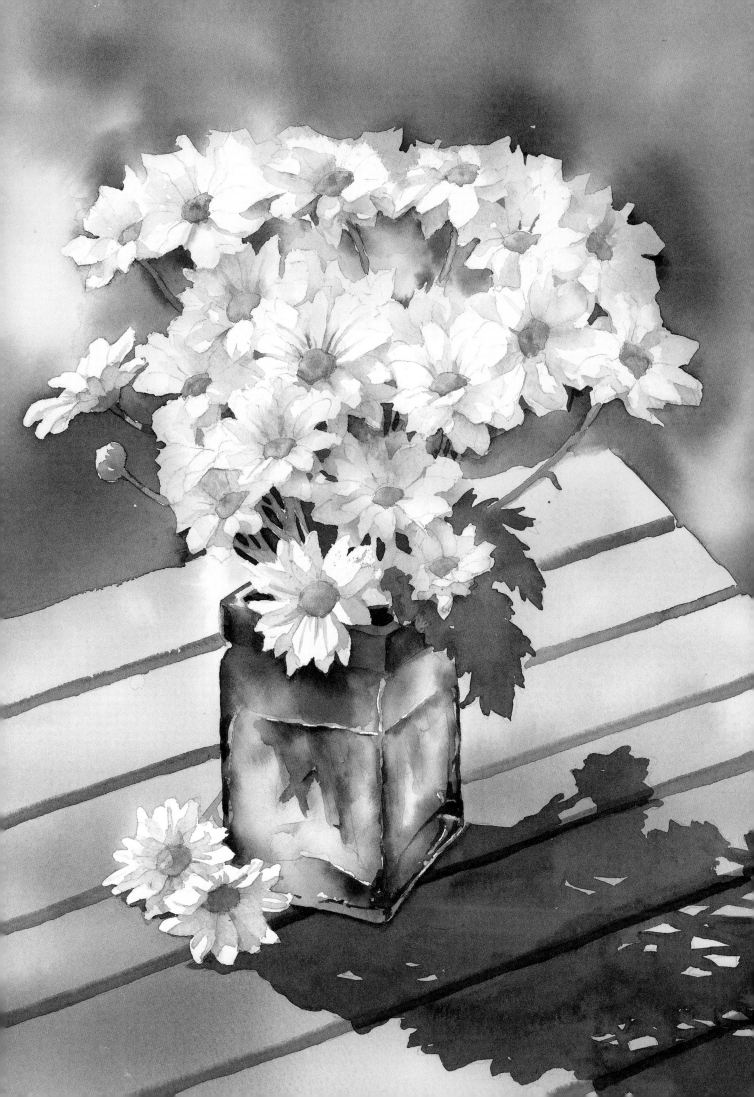

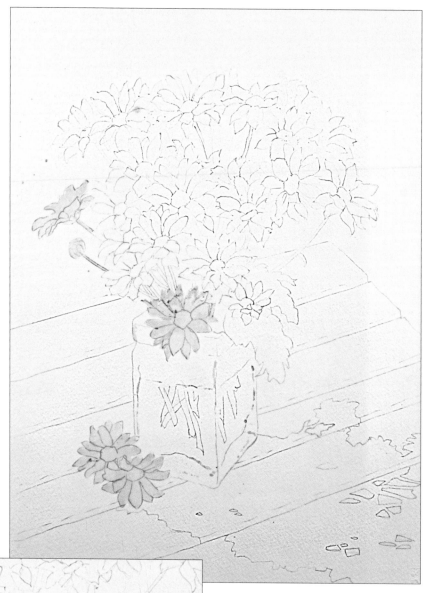

1 Sketch the basic shape on to your
watercolour paper using a 2B pencil.
Secure it to the board using masking
tape, then use a nylon size 3 round to
apply masking fluid as shown.

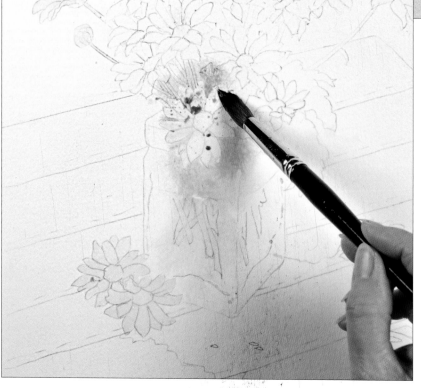

2 Prepare a yellow well of aureolin
and quinacridone gold for the light
in the vase, and separate wells of
phthalo turquoise and perylene
maroon. Wet the whole paper
thoroughly using a 16mm (⅝in)
filbert, then use a size 12 round to
lay in the yellow mix for the sunlight
in the vase. Drop in a little phthalo
turquoise above it over the masked-
out flowers, working wet-into-wet.

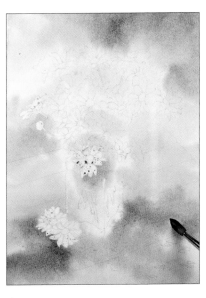

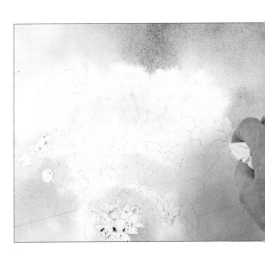

3 Continue laying in dilute phthalo turquoise over the background, avoiding the daisies.

4 Add in some perylene maroon to vary the background, then mix perylene maroon and phthalo turquoise together for some darker touches.

5 Dab kitchen paper on to the flowers to lift out excess paint, then allow to dry.

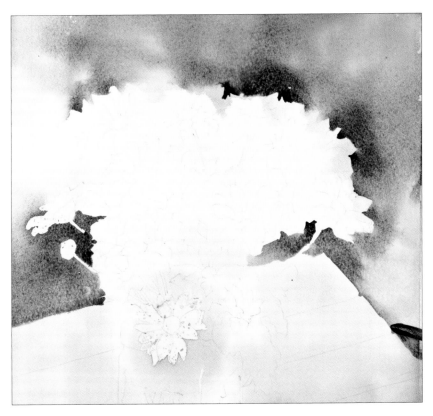

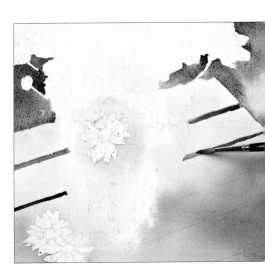

6 Make a dark mix of phthalo turquoise, quinacridone gold and perylene maroon. Wet the paper around the flowers with the size 12 round, working right to the edge of the paper, then drop in the dark mix with a size 10 round to delineate the flower petals.

7 Use the tip of the size 10 brush to paint darks between the slats of the table, then use a wet size 6 round to blend and soften the line a little.

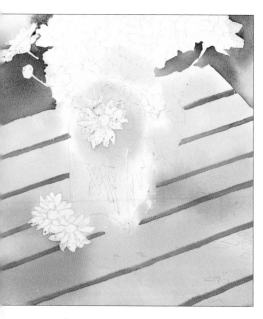

8 Paint the other lines in the same way and leave to dry.

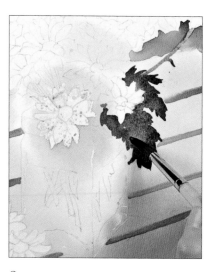

9 Use a wet size 10 round to wet the leaves, and a second size 10 to drop in phthalo turquoise and quinacridone gold, allowing them to mix on the paper to make a green.

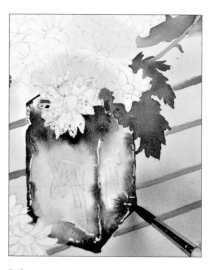

10 Wet the vase, then drop in darks at the edges. Add touches of the sunlight mix in the centre.

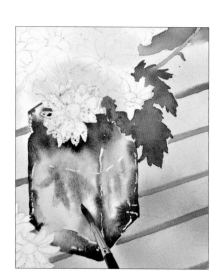

11 Use quinacridone gold and phthalo turquoise to make a green. Use a size 6 round to apply it to the sunlight mix wet-into-wet to suggest stalks in the water.

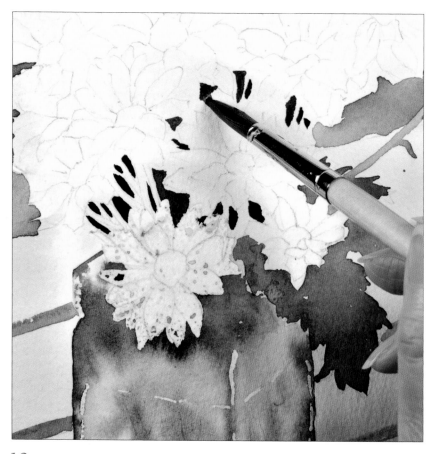

12 Use fairly strong mixes from the dark well to begin to fill in the spaces between flowers, suggesting stems and stalks with negative painting.

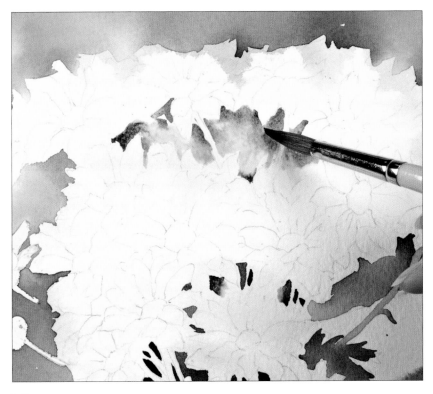

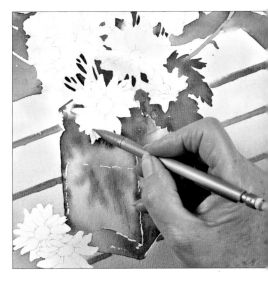

13 For the larger gaps at the top of the flowers, apply a little water, then add the paint wet-into-wet.

14 Allow the painting to dry, then use a clean finger to rub away all of the masking fluid. Use a 2B pencil to reinstate the details on the flowers.

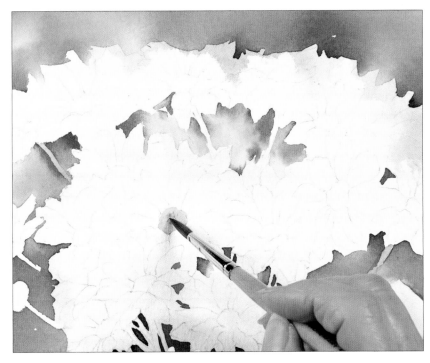

15 Prepare the following wells: a green well of phthalo turquoise and quinacridone gold; a sunlight well of quinacridone gold and aureolin; and an orange well of quinacridone gold and permanent rose. Use a size 10 round to apply the sunlight mix to the centre of one of the daisies.

16 While the centre is still wet, add in a touch of the green mix with a size 6 round. Add the orange mix towards the bottom, then allow to dry.

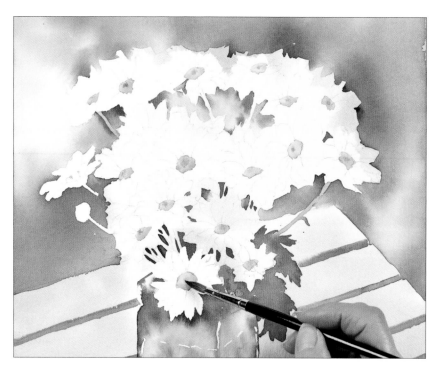

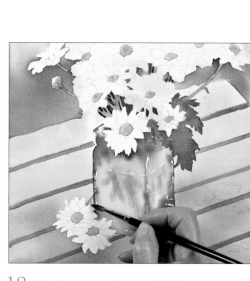

17 Paint the centres of the other daisies in the same way.

18 Use the green mix to model the stems and the bud on the left with a size 6 round.

19 Make a shadow well of cobalt blue and touches of permanent rose and aureolin. Use this to paint in the darkest shadows on the daisies. Apply the paint with a size 6 round, then blend it down with a wet size 10 round. Drop in some dilute touches of pure permanent rose and aureolin to vary the hue and add interest.

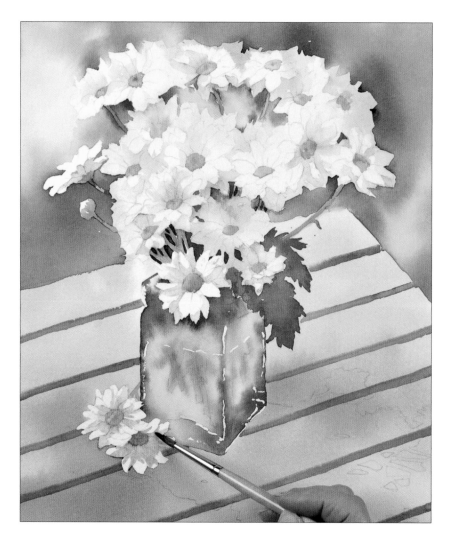

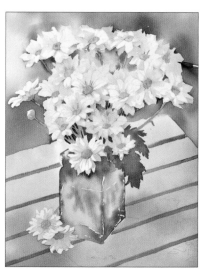

20 Delineate the petals using a size 6 round, adding a touch of Winsor violet to darken the mix.

21 Use a putty eraser to rub away the pencil lines.

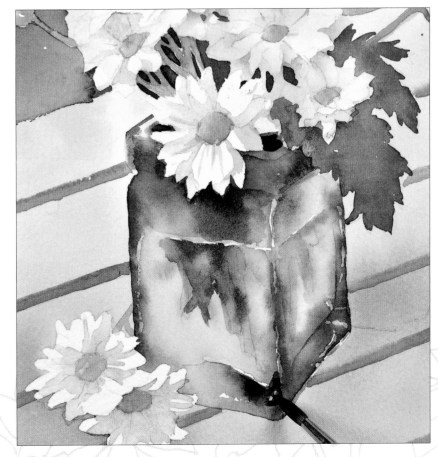

22 Use the shadow well to detail and model the vase. Use a wet size 6 to blend and soften the colour, and use the green well to detail the stems.

TIP

It is important to use plenty of water to blend out the pigments and achieve a glassy look.

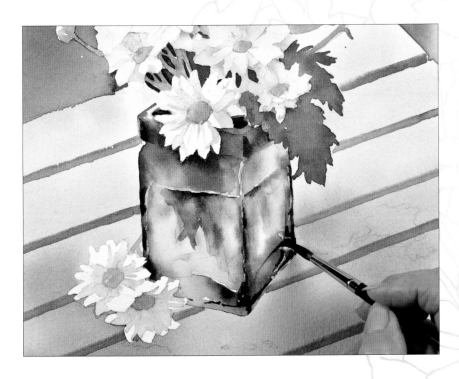

23 Once dry, add a few dark strokes on the vase to increase the glassy impression.

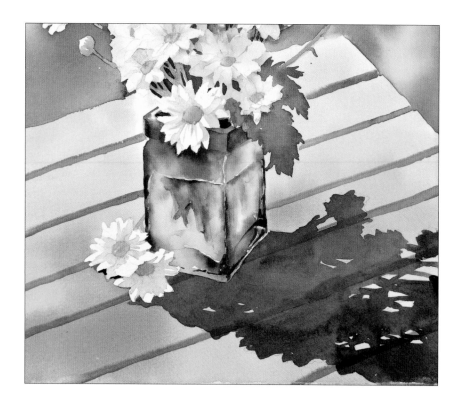

24 Make an extremely dark mix of perylene maroon and phthalo turquoise to paint the shadow cast by the vase and flowers. Make plenty of the mix and keep it fairly dilute.

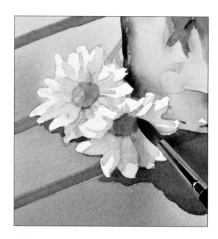

25 Use the cobalt blue and permanent rose from the shadow well with a size 6 round to detail the daisies on the lower left.

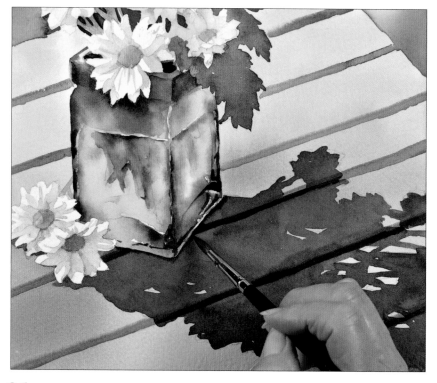

26 Still using the size 6 brush, make a stronger mix of perylene maroon and phthalo turquoise and use it to deepen the shadows between the slats where the shadow of the vase falls across them. Use the same mix to paint a fine line between the vase and table. This will anchor the vase.

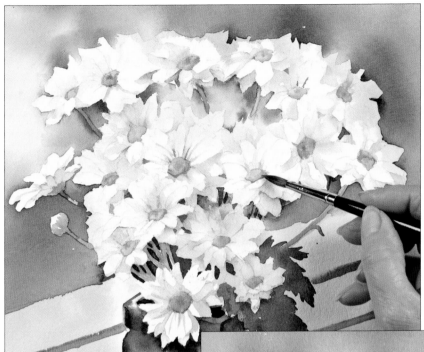

27 Strengthen the centres of the daisies with the sunlight well (quinacridone gold and aureolin) and the orange well (quinacridone gold and permanent rose).

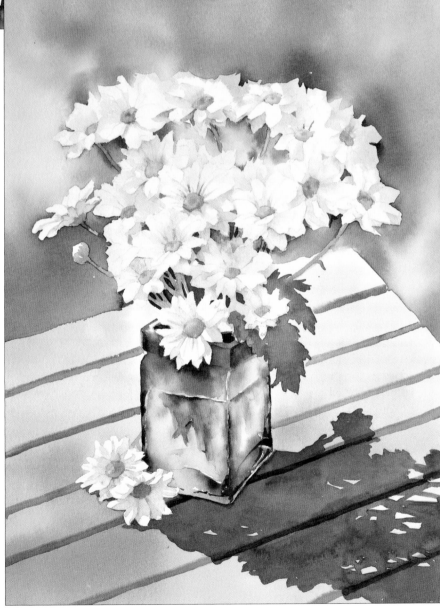

28 Make any final adjustments that you feel necessary to finish.

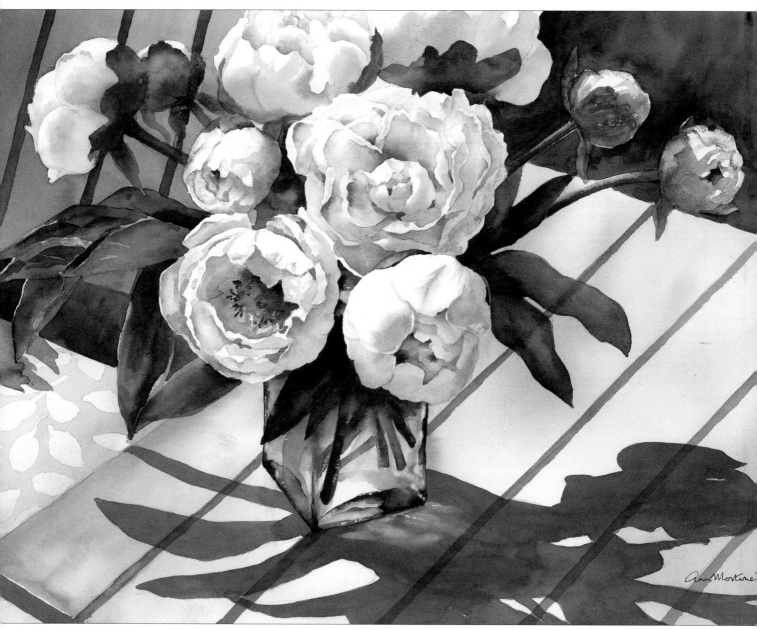

Sunlit Peonies

49 x 37cm (19¼ x 14½in)

*Here is another composition based on the same table and vase, but with peonies in place
of the daisies. The peonies have a lot of reds and pinks in them which complement the blue
table well, and once again the cast shadow acts as the focal point.*

*Notice the point of light in the shadow near the base of the vase. This was achieved by gently
scrubbing the area with a damp brush, then lifting out the colour with a clean, dry piece of
kitchen paper.*

Autumn Jug

36 x 27cm (14¼ x 10½in)

I brought together these flowers, leaves and fruit from the garden to provide inspiration and colour reference for an autumn painting workshop. I realised the collection was attractive in its own right, and so I decided to paint it.

Even in this vase arrangement, I have been able to use negative painting to add depth and to delineate some of the shapes. The white Japanese anemones are important, as they lift the composition and give it tonal contrast.

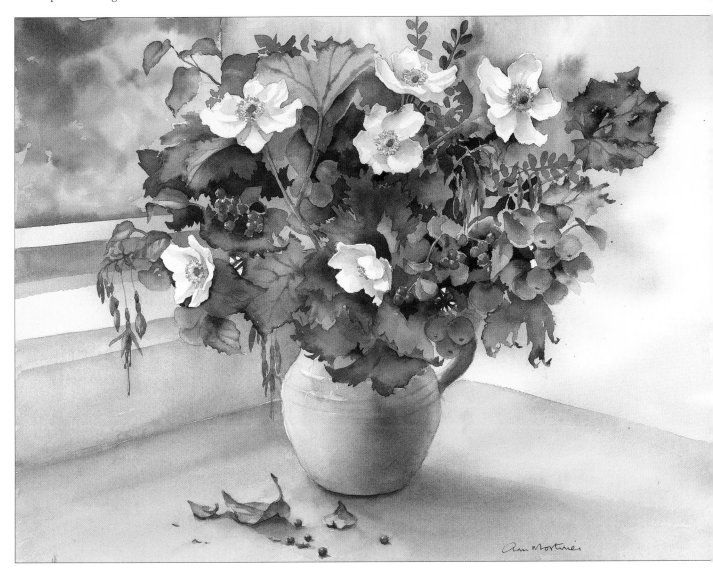

Doorway

This project is a good example of how a simple subject can be personalised and embellished in several different ways to make different paintings.

The doorway is in a village in Norfolk and on the day I took this photo there was a wonderful shadow being cast across it which made a perfect focal point.

I have painted this doorway many times with different flowers around it. But it is the shadow which always brings it to life because it highlights elements such as the latch, struts, studs and even the peeling paintwork, all of which produce a delightful three-dimensional effect. I think you will enjoy this subject.

I took elements from several photographs in my collection for this composition. When deciding which photographs to use, I checked that the light was coming from the same direction in all of them.

In the door sketch I have left out the wall in front of it shown in the photograph (top right). It is useful to sketch features like the door latch in detail in order to observe how they work and how the shadows are cast.

*Opposite
The finished painting.*

72

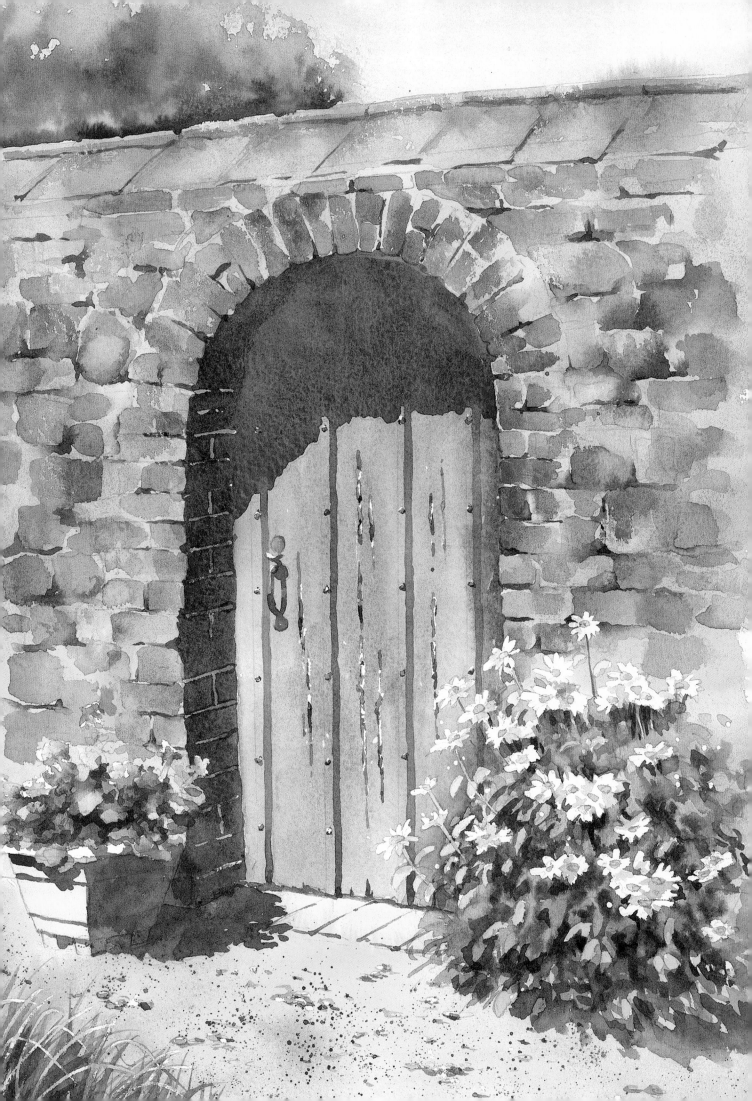

You WILL NEED

425gsm (200lb) Not finish
watercolour paper 28 x 38cm
(11 x 15in)
2B pencil
Board
Masking tape
Masking fluid
Kitchen paper
Wax candle
Scrap paper
Palette knife
Brushes:
nylon size 3 round, 16mm (⅝in)
filbert, size 12 round, two size 10
rounds, size 6 round
Watercolour paints:
raw sienna, permanent rose, cobalt
blue, aureolin, Hooker's green dark,
French ultramarine, burnt sienna,
viridian, quinacridone red

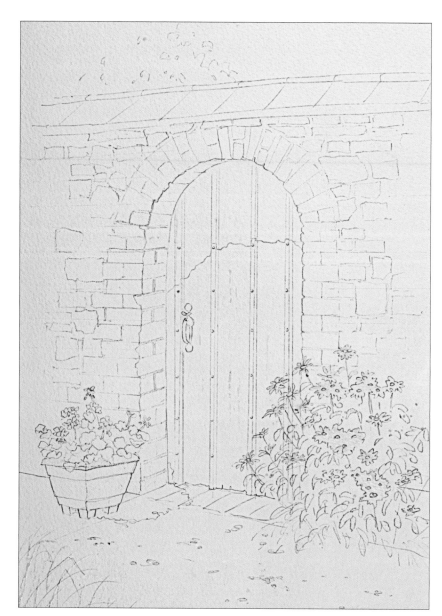

1 Draw the basic sketch on to your watercolour paper using the 2B pencil. Use masking tape to secure it to a board and apply masking fluid to the daisy flowers on the right, the pelargoniums in the pot, on the studs and cracks of the door, in the mortar in the doorway and on the stones and grasses in the foreground. Use a nylon size 3 brush to apply the fluid.

2 Prepare wells of raw sienna, permanent rose, cobalt blue and aureolin. Prepare a green well of unmixed Hooker's green dark; and a dark well of French ultramarine and burnt sienna. Use the 16mm (⅝in) filbert to wet the paper thoroughly. Allow the water to soak in, then re-wet it. Use the size 12 round to drop in cobalt blue to start the sky.

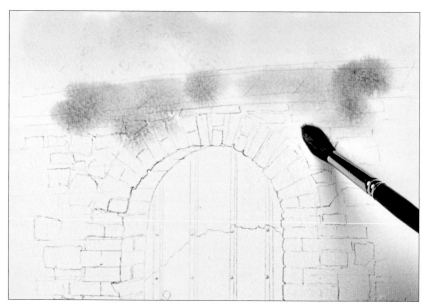

3 Still using the size 12 round, add touches of raw sienna and then the green mix to the top of the wall.

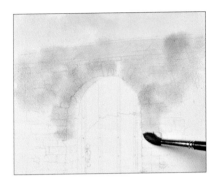

4 Work down the wall, introducing the other colours as you progress. Use more permanent rose around the doorway.

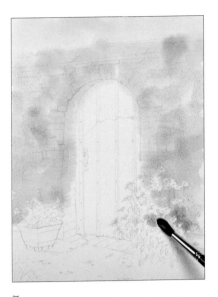

5 Work all the way down the wall, and use aureolin and the green mix to start the flower foliage on the right.

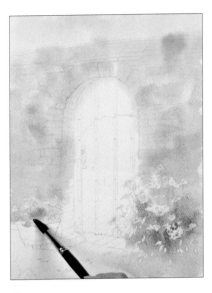

6 Continue filling in this area, and use the same mix to start the flower foliage on the left.

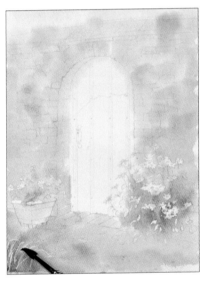

7 Blend raw sienna, burnt sienna and the dark mix to cover the ground, then add a flourish of Hooker's green dark to the grasses on the left.

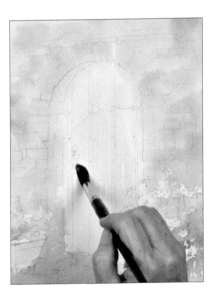

8 Lay in a wash of aureolin over the door.

9 Apply wax to the stones where they catch the light. This will resist the watercolour and suggest texture.

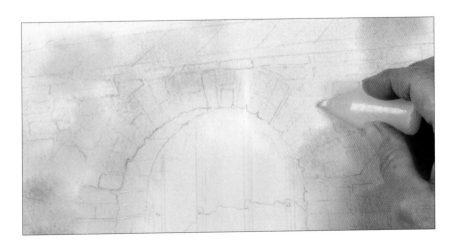

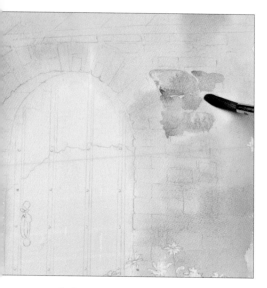

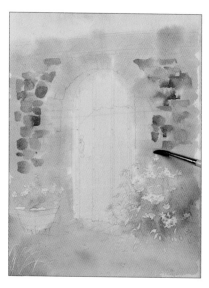

10 Using all of the wells and a size 10 round, begin to paint the wall. Concentrate lighter, more dilute colours to the top left of the stones, as these are towards the source of light; and stronger, deeper tones towards the lower right.

11 Switch to the size 6 round brush and use the darkest tones to suggest the mortar between the stones, blending it into the stonework.

12 Switch from area to area and continue to fill in the wall. Jumping like this keeps the painting loose and fresh.

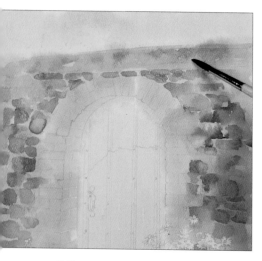

13 Fill in the top of the wall with the same mixes, adding a little water to make each more dilute.

14 Use the size 6 round to work more darks into the mortar to provide contrast.

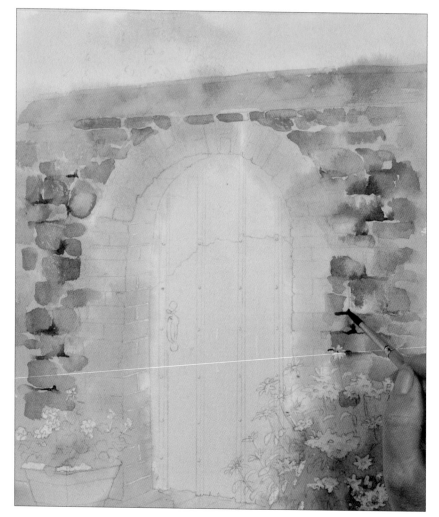

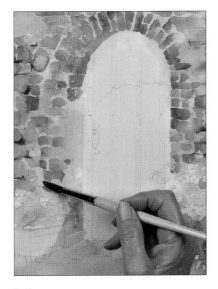

15 Switch to the size 10 brush and use warm hues – raw sienna, permanent rose and burnt sienna – to paint the brickwork round the door. Work carefully, but not fussily, with a fairly dry brush to suggest texture.

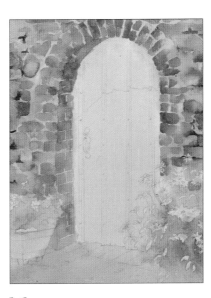

16 Introduce hints of mortar and shading with French ultramarine and burnt sienna across the whole wall, including the arch. Allow to dry.

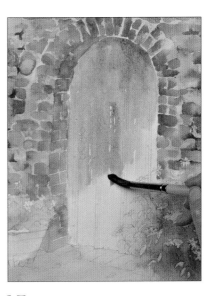

17 Wet the whole door with clean water, and add a dilute mix of viridian and French ultramarine wet-into-wet. Allow to dry.

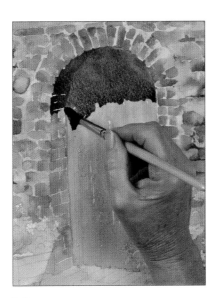

18 Make a large amount of a shadow mix, made from French ultramarine and burnt sienna. Use a size 10 round to paint a swathe of shadow across the top of the door.

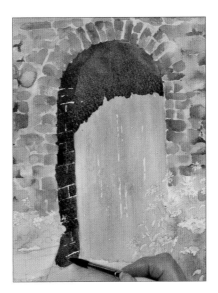

19 Work down the inside of the recess, suggesting the irregular broken brickwork by working into the mortar.

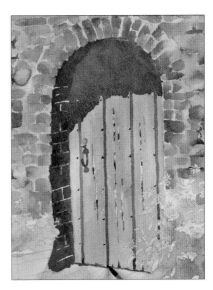

20 Switch to a size 6 round and paint the details on the door like the reinforced areas, studs, cracks, latch and the bottom of the door.

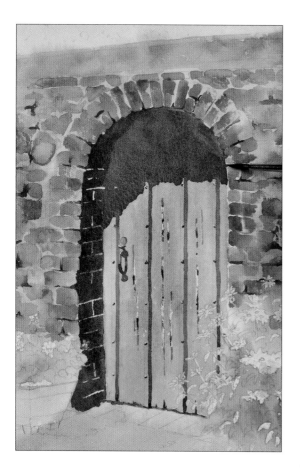

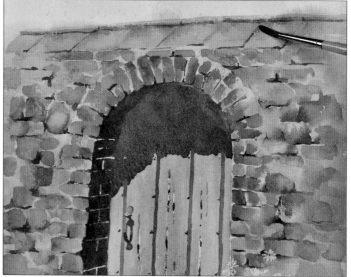

21 With the shadow on the door in place, we need to adjust the tones in the arch. Use the dark mix of French ultramarine and burnt sienna with the size 6 round to redefine the mortar.

22 Use the same mix to detail the coping stones on top of the wall, then use a dry brush to add touches of raw sienna, permanent rose and cobalt blue to detail the coping stones.

23 Cover the painting with scrap paper, leaving the path at the bottom exposed. Make a mix of cobalt blue, permanent rose and raw sienna. Brush it on to your palette knife, and the pluck the end to spatter the paint on to the path.

24 Use the tip of a dry size 6 round to draw the larger spatters horizontally to create cast shadows.

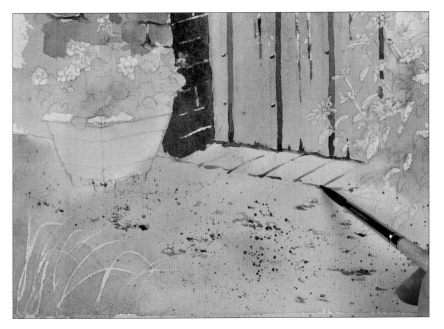

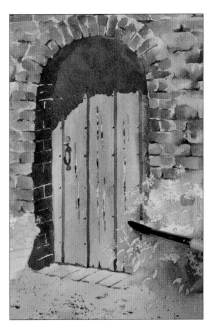

25 Remove the scrap paper and use the same colours to add shading to the masked-out pebbles with the size 6 round. The same methods can be used to add some stony details in the path, and to delineate the stones in front of the door.

26 Detail the edge of the door with French ultramarine and viridian. Wet the right-hand side with clean water, then drop in the colour and draw it across.

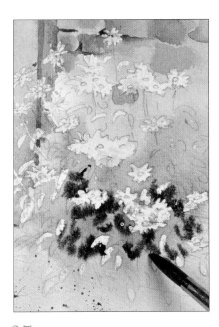

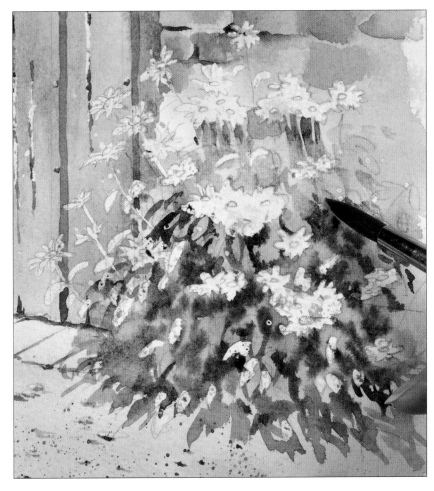

27 Wet the whole area of the daisies with the size 10 brush, and use negative painting with a dark well of burnt sienna, Hooker's green dark and French ultramarine; and a yellow well of aureolin and burnt sienna to shape the foliage.

28 As the area dries, you can control the paint more easily, so pick out the daisy stems with negative painting and add leaves.

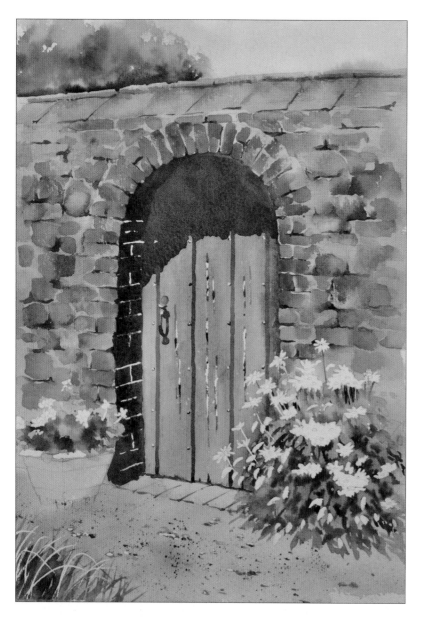

29 When the area is completely dry, overpaint and develop the negative shapes to tighten the work. Use the same techniques on the flowerpot, foreground grasses and background tree. Allow the painting to dry completely, then remove all of the masking fluid from the painting.

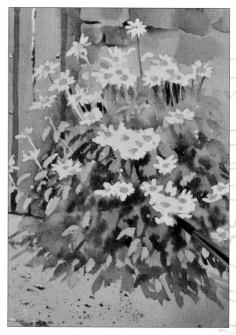

30 Using a size 6 round, add more aureolin to the green mix. Paint the leaves and stems, and use an aureolin and raw sienna mix to paint the centres of the daisies.

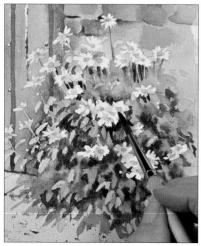

31 Using a strong mix of Hooker's green dark, French ultramarine and burnt sienna, cut into the leaves and daisies with the tip of the size 6 round brush to delineate them.

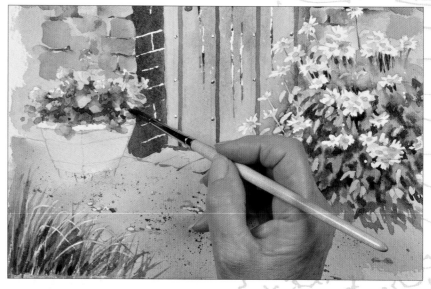

32 Use the same green mixes to detail the foreground grasses and the pelargonium foliage, then paint the flowers with quinacridone red. Add a mix of quinacridone red and French ultramarine wet-into-wet for shading and variation.

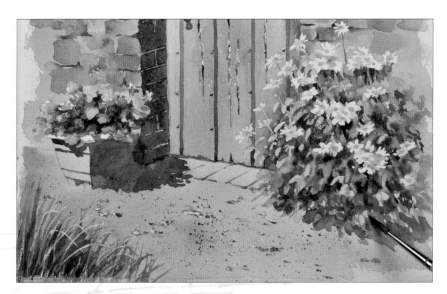

33 Use a mix of French ultramarine and burnt sienna with some Hooker's green dark to paint the shadows on and near the flowerpot, on the mortar in the arch, below the daisies and on the door.

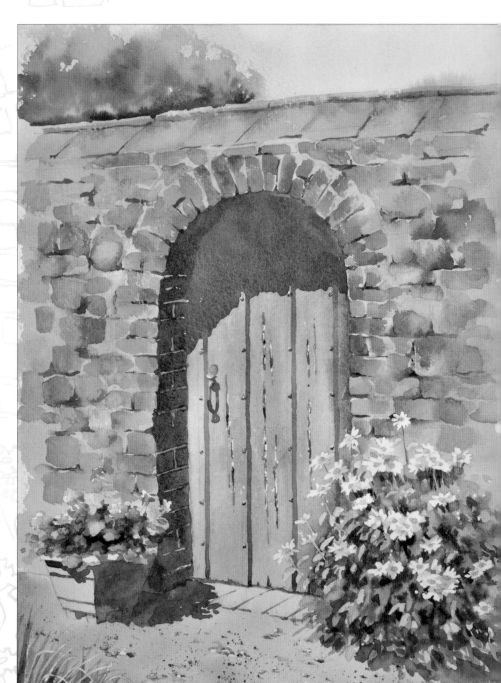

34 Make any final tweaks to the picture that you feel necessary. Erase the pencil lines and touch in a few more stones on the path.

Green Door

26 x 36cm (10 x 14¼in)
An example of the same subject, painted with different accompanying flowers.

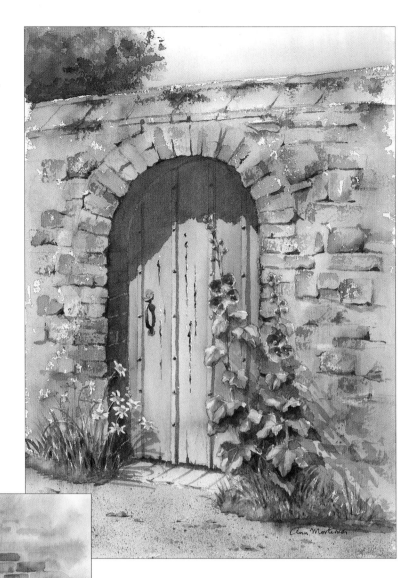

Cottage Window

24 x 34cm (9½ x 13½in)
Like doorways, windows are a fascinating subject to paint. Here, the window is decorated with a window box full of bright blooms and the shutters provide contrast and interest. All of the details of the flowers in the scene have been suggested using wet-into-wet techniques.

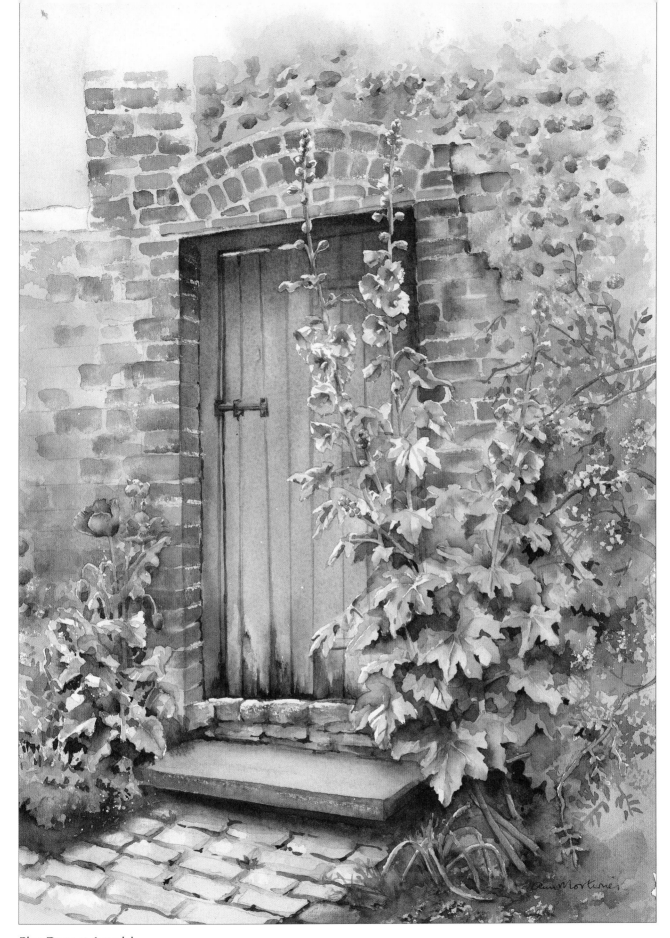

Blue Door at Arundel

26 x 36cm (10 x 14¼in)
*The entire hollyhock plant – leaves, stems and flowers – was masked out at the beginning
to allow me to paint the door and wall freely. I like the contrast of the pink flowers against
the blue door and I enjoyed creating the textures of the flint stone wall.*

Hellebores

Hellebores are among the first flowers to emerge from the winter gloom in early spring. Their waxy white blooms provide a stunning contrast to the bare, dark-coloured winter soil in a garden or to the sombre bed of fallen leaves in a woodland glade.

Because they flower when the weather is cold and we can not get out much, we often have to resort to various strategies to plan compositions and find source material. Here I have used two photographs: one of hellebores, and one of fallen leaves, gathered in autumn. The leaves were kept in a box in the studio over winter and I used their dried, crinkled shapes for reference to create the feel of a leaf-littered woodland floor.

I love painting these white flowers with their wide open faces and eager stamens which seem to be seeking out the sun. The stamens cast interesting shadows on the white petals. (Purists will know that these are in fact the sepals of the flower and that the petals are the tiny green protuberances right in the centre.)

With this subject there is enormous scope for tonal contrast, which is what I love most of all about watercolour painting.

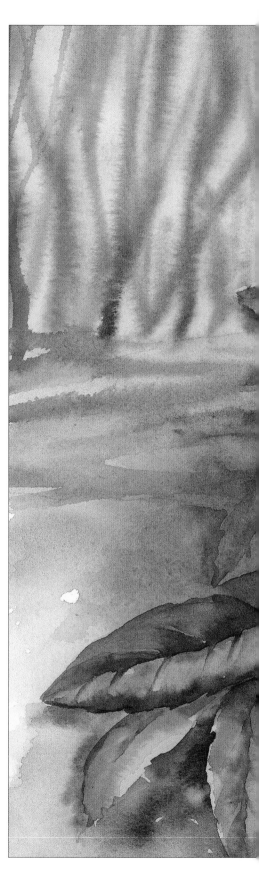

This photograph was taken next to a sunny window and it provided me with reference for the flower positions and the cast shadow of the stamens in their centres.

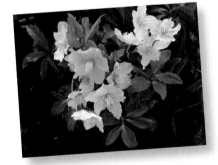

This photograph shows the hellebores' leaf formation very well.

Gathered leaves provide valuable reference material.

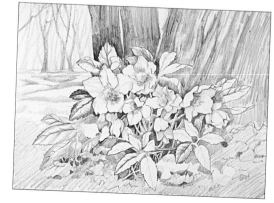

This sketch helped me to work out how I wanted the composition to appear, and to check the balance of light and dark tones within it.

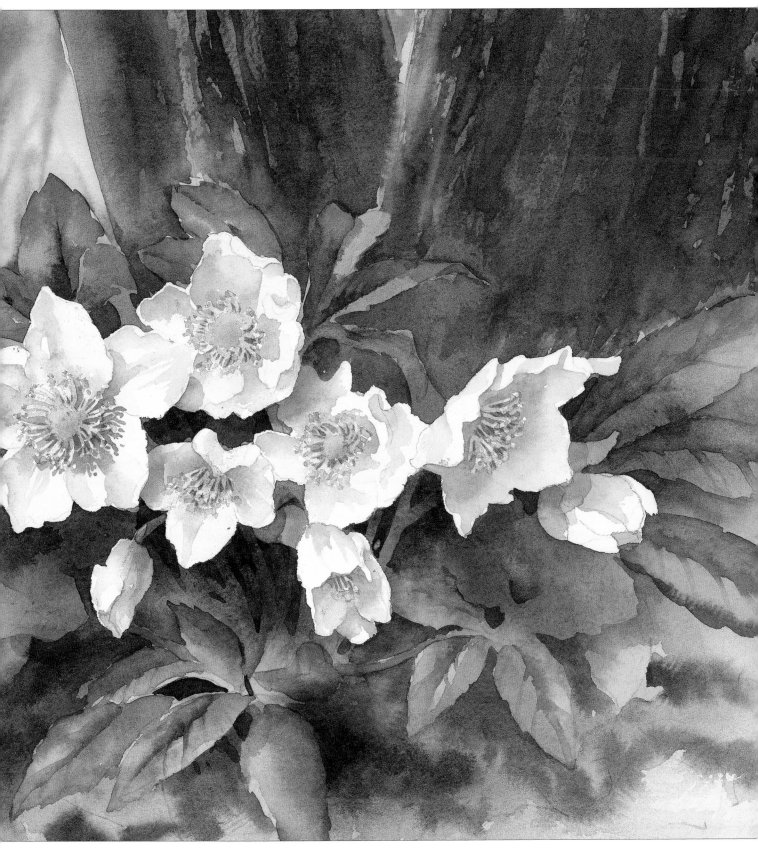

The finished painting.

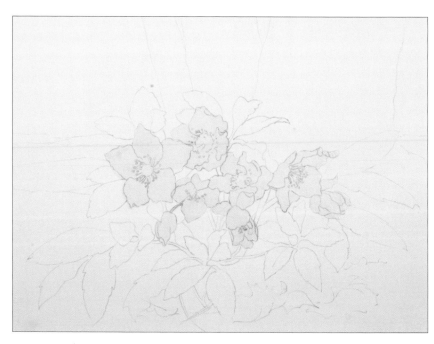

1 Use a 2B pencil to sketch out the main shapes on the paper. Secure it to the board with masking tape, prop the board up and apply masking fluid as shown using the nylon size 3 brush. Prepare a well of raw sienna and aureolin, allowing them to merge slightly, but keeping them mostly separate. Do the same with French ultramarine, burnt sienna and Winsor violet for a dark well; cobalt blue and permanent rose for a blue well; raw sienna, aureolin and Hooker's green dark for a green well; and some alizarin crimson on its own.

2 Wet the paper thoroughly with the 16mm (⅝in) filbert, then use the size 12 round to apply raw sienna and cobalt blue to the sky area, adding touches of Winsor violet.

3 Working wet-into-wet, apply raw sienna and burnt sienna to the treeline.

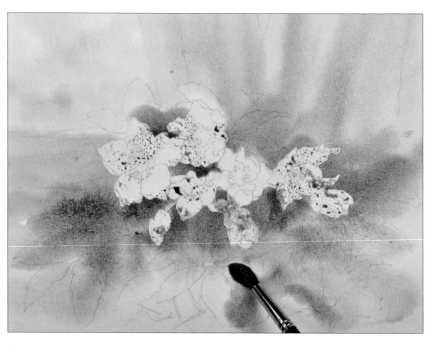

4 Use the green well to add colour around the leaves, then use raw sienna, Winsor violet and burnt sienna for the ground area.

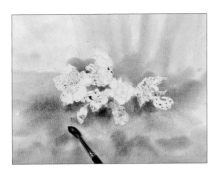

5 Continue adding raw sienna and the colours of the dark well between the leaves of the main flowers. This will heighten the contrast between the leaves and flowers in the finished picture.

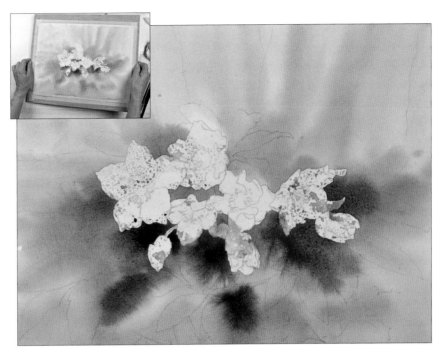

6 Pick up the board and tilt the painting to encourage the colours to merge (see inset). Put it back down and add some strong alizarin crimson, French ultramarine and burnt sienna, mixing them on the paper. Allow the painting to dry completely.

TIP

Because I allow my colours to bleed into one another in the wells, the colours listed are approximate – tinges and combinations of the other colours in the wells will affect the exact hues. Do not worry! As long as the colours are not muddy and mixed in your wells, you will get fresh, natural colours from the purer areas, as well as beautiful combinations where they merge.

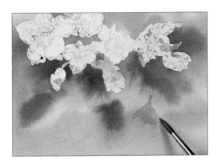

7 Using the size 10 brushes, lay in some raw sienna next to one of the leaf outlines, drawing it round the leaf.

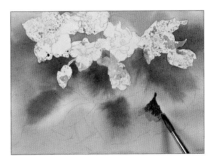

8 While the raw sienna is wet, use the other size 10 brush to add a mix of colours from the dark well.

TIP

There is no replacement for good source material, so go into the woods and study the appearance of the woodland floor to get an idea of the texture you are capturing.

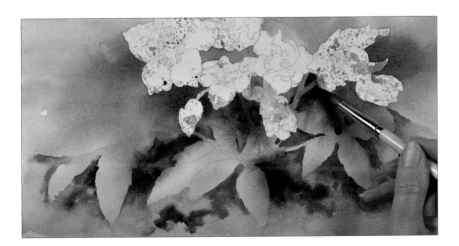

9 Repeat this over the rest of the woodland floor, varying the hues and strength of the colours you are using from the dark well. By painting the negative shapes around them in this way, the hellebore leaves are made to emerge from the background of the woodland floor.

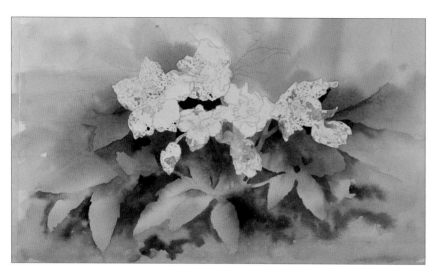

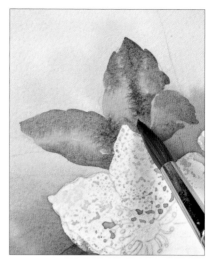

10 Using clean water instead of the raw sienna, and the green well and burnt sienna instead of the dark well, repeat the process across the foliage in the mid-area of the painting.

11 Paint the leaves above the flowers with aureolin, then drop in colours from the green well wet-into-wet.

12 Do the same on the leaves in front of the tree, drawing the wet paint across to form the veins.

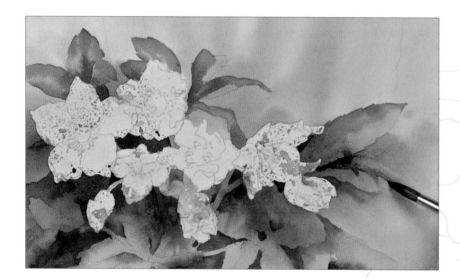

13 Use the same colours and techniques across the remaining leaves.

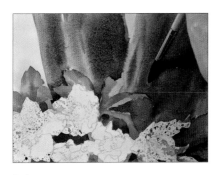

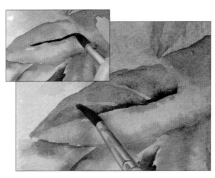

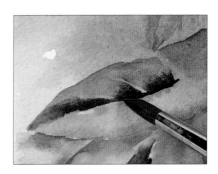

14 Still using the size 10 round brushes, wet the trees with clean water before using the dark well and raw sienna to make vertical strokes and diamond shapes on the trunks for a bark effect. Emphasise lighter colours on the left and darker ones on the right.

15 Use the tip of a size 10 brush to draw a line of Hooker's green dark along the midrib of one of the leaves on the lower left (see inset). Add touches of French ultramarine and burnt sienna wet-into-wet, then use a damp size 6 brush to draw the paint up the leaf, leaving gaps to suggest side veins.

16 Add more dark green with the size 10 to strengthen the shading, then use a wet size 6 to draw side veins down over the light side.

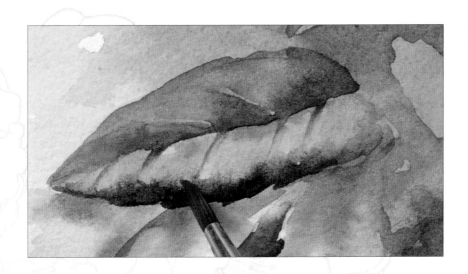

17 Apply dark green along the bottom of the leaf with the size 10 brush, then draw the colour up with a wet size 6 brush to emphasise the side veins on the lighter half. Allow to dry.

18 Paint some of the other leaves in the same way.

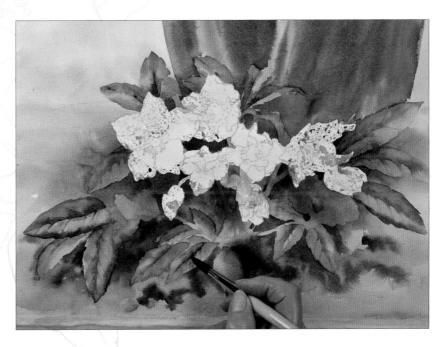

19 Draw the side of the size 10 dry brush down over the trees in broken strokes to bring out the texture of the paper and suggest bark. Use the colours from the dark well, with an emphasis on burnt sienna.

20 Wet the sky area with clean water, then use the size 10 round brushes to suggest misty tree shapes and shadows in the background.

21 Allow the painting to dry completely, then carefully rub away all of the masking fluid with your finger.

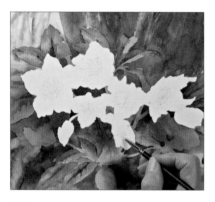

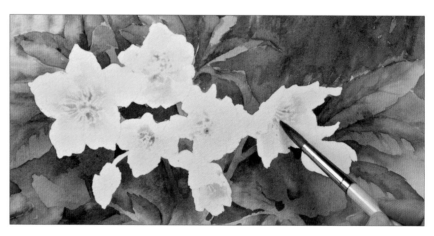

22 Use the size 0 colour shaper to apply masking fluid to the stamens of the hellebores, and allow to dry.

23 Use a size 10 round brush to wet the flowers with clean water and apply a dilute wash of aureolin to the centres. Vary the hue with touches of the green well.

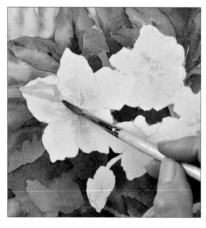

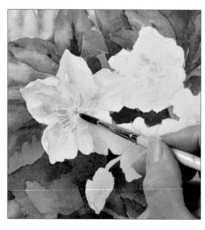

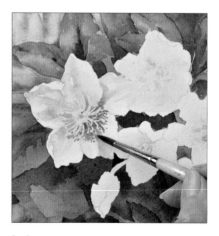

24 Make a dilute mix of cobalt blue with a touch of permanent rose. Use the size 6 to suggest shading on the edge of the leftmost hellebore's petals.

25 Draw the colour in with a wet brush to blend and soften the transition, then paint the other petals in the same way.

26 Use a stronger mix of the same colour to strengthen the shadows in the centre of the hellebore and to paint in the shadows cast by the stamens.

27 Paint the other flowers in the same way, adding a touch of permanent rose to the base of the opening buds at the bottom. Paint the small leaves using the colours in the green well.

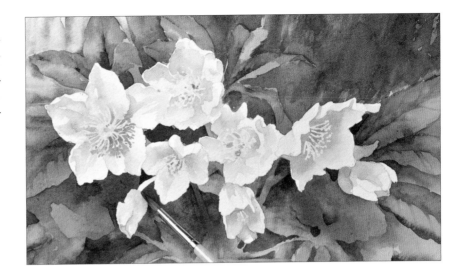

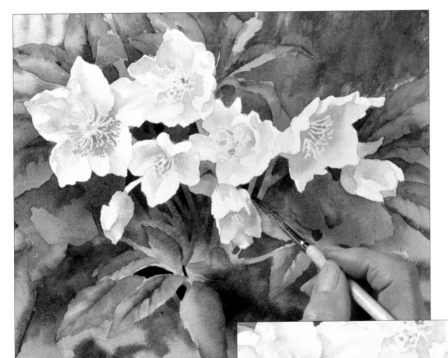

28 With the flowers in place, use the colours from the dark well and the size 6 round to bring out the stems and foliage below them with negative painting.

29 Paint the stems with raw sienna and drop alizarin crimson in wet-into-wet.

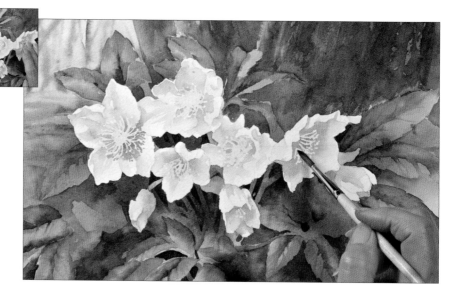

30 Use your fingers to rub away the masking fluid from the stamens (see inset), then paint them with a thin wash of aureolin, using the size 6 round. Allow to dry.

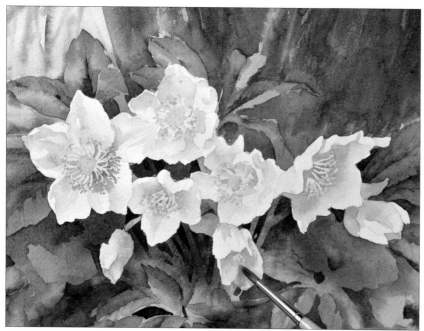

31 Add a little permanent rose to warm the aureolin. Wet the flower centres and drop in the warm colour. Dot the same colour into the ends of the stamens.

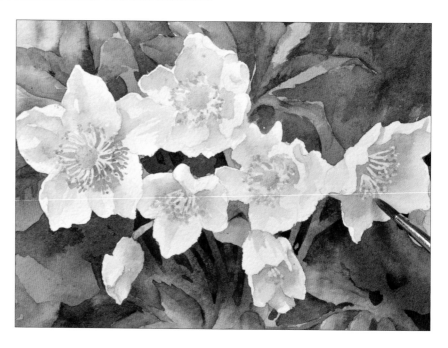

32 Warm the colour with a little more permanent rose and use it to shade the yellow areas.

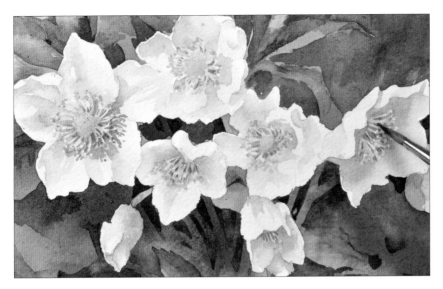

33 Add a dilute touch of the shadow mix to the lower right of each flower centre, away from the source of light. Use a stronger shadow mix in between the stamens with the tip of the size 6 round brush.

34 Make any final touches to the piece that you feel necessary, then remove the masking tape to finish.

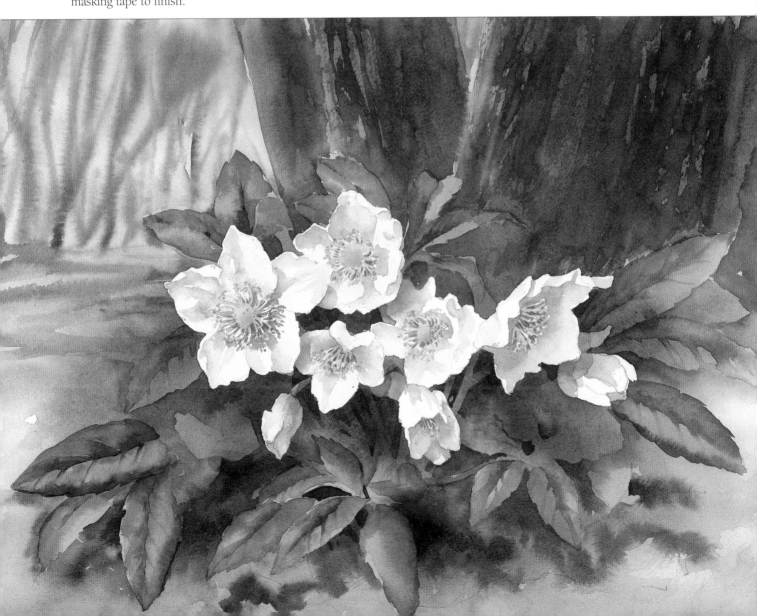

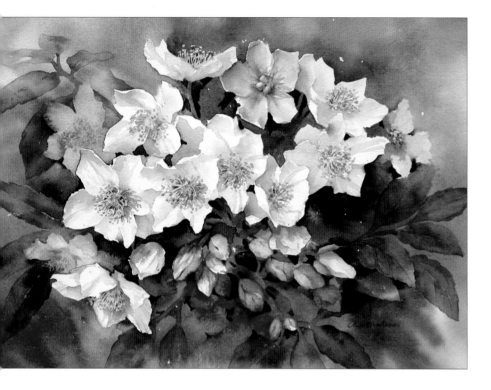

Hellebores

37 x 27cm (14½ x 10½in)

In this painting of hellebores in my garden, I wanted to bring out the intense tonal contrast between the blooms and the surrounding dark winter soil and deep green foliage. The buds and stems are streaked with crimson, and I used this colour in the background wash along with golds and yellows for a unified effect.

Opposite

Snowdrops in Woodland

21 x 30cm (8¼ x 11¾in)

This picture has a lot of information to take in, from the detailed snowdrops and fallen leaves in the foreground to the distant flowers and trees. It was therefore very important to summarise the distant features with suggestive tones and gestural marks rather than overloading the composition with too much detail.

Primroses

35 x 26cm (13½ x 10in)

These primroses were nestled beneath a mossy wall. I love their pale yellow smoothness against the bumpy texture of their leaves. To achieve this effect, I masked out the primroses and created texture in the background using salt, wet-into-wet and dry brush techniques. The dark crevices between the stones and among the leaves and twigs are important in creating depth in the painting.

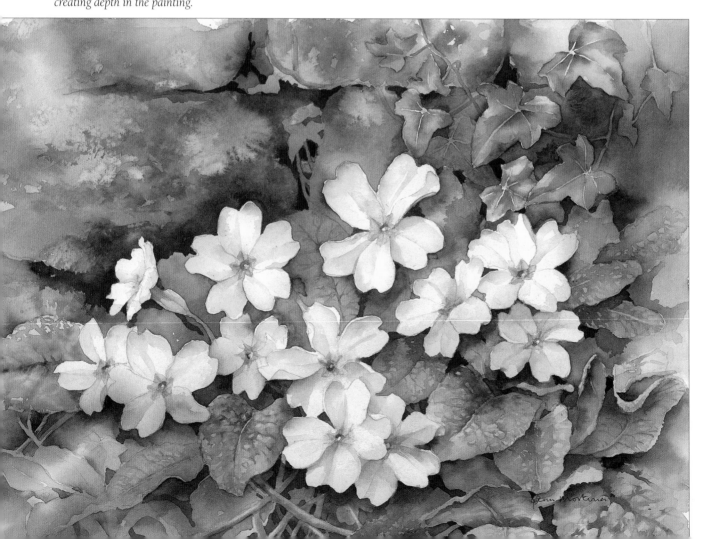

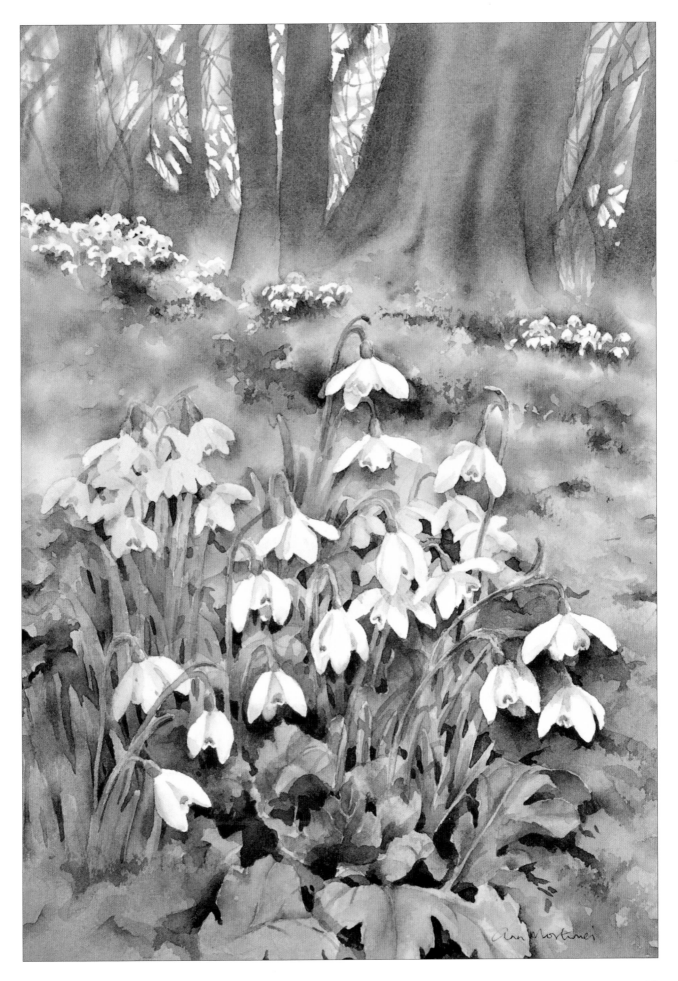

Index

Water Lilies
18 x 27cm (7 x 10½in)
The contrast of the white waterlily against the dark depths of the water was what attracted me to this subject. It was an interesting challenge to make the lily pads appear to rest on the surface of the water, and I am particularly proud of the effect of the water bubbling up on to the surface of the leaf on the bottom right.